MW00476596

Called to Peace

A Survivor's Guide to Finding Peace and Healing After Domestic Abuse

By Joy Forrest

BLUE INK
PRESS

I have tried to recreate events, locales and conversations from my memories of them. In order to maintain their anonymity in some instances I have changed the names of individuals and places, I may have changed some identifying characteristics and details such as physical properties, occupations and places of residence.

Published by Blue Ink Press, LLC

Copyright © 2018 Joy Forrest

All rights reserved, including the right of reproduction in whole or in part in any form.

CAll scripture quotations, unless otherwise indicated, are taken from The Holy Bible, New International Version ®, NIV ®. Copyright © 1973, 1978, 1984 by Biblica Inc.™ Used by permission of Zondervan. Scripture quotations marked (NKJV) are taken from the New King James Version ®. Copyright © 1982 by Thomas Nelson Inc. Used by permission. All rights reserved. Scripture quotations marked NASB are taken from the New American Standard Version ®. Copyright © 1960, 1962, 1963, 1968, 1971, 1972, 1973, 1975, 1977, 1995 by The Lockman Foundation Printed in the United States of America

Cover design by Cover Design by Dee Graphic Design
www.deegraphicdesign.com

www.blueinkpress.com

ISBN: 1-948449-01-3
ISBN-13: 978-1-948449-01-4
Library of Congress Control Number: 2018935778

Table of Contents

Preface

This book contains my own experiences with domestic violence, as well as stories from precious survivors I have met over the years. In these accounts, names and identities have been changed except for those of my children, and the wonderful helpers God sent along the way. Without them, I am not sure we would have made it out, and I am forever grateful for their help.

Please note that my intention in writing this book is to help people better understand the dynamics of domestic violence, not to bash my ex-husband. This happened over twenty years ago, and my children tell me he is different these days. The point of telling this story is to show how abuse progresses over time, and to show that God can, and will, redeem any situation. Also, it is not my intent to criticize pastors or counselors whose counsel I share in the book. I fully understand how easy it is to be fooled by these situations, and one goal of the book is to show how tricky dealing with domestic violence can be, especially for those without specialized training.

As you read, you will notice that I refer to victims and survivors as females and to perpetrators as males. Part of the reason for this is that my own experience has been working, almost exclusively, with female victims. This is not to deny female against male abuse. However, when it comes to physical domestic violence and injuries

reported, statistics reveal that over 90 percent of perpetrators are male. Also, when it comes to counseling within the church, gender is an important topic because so many abusers use scripture as a tool to dominate their wives. In my own case, my misunderstanding of scripture kept me in a dangerous place for far too long, and I have seen many other women with the same struggle. This book is written primarily for women of faith who need to see God's heart for the oppressed and for those who desire to help them. For the sake of simplicity, and to focus on my intended audience, I will use male pronouns to refer to offenders and female pronouns to refer to victims/survivors.

I think it is important to note that while my healing came primarily through reading scripture and prayer, most of the women I work with on a daily basis need individual counseling. By the time I separated from my ex-husband the final time, I had been a Christian for nearly twenty-five years, and I knew how to apply scripture to my life. Still, it was a very difficult path, and I did have some very wise friends who offered counsel. Two words of caution should apply when it comes to seeking counsel. First, be careful to choose a counselor who understands and has specific training on the dynamics of domestic abuse. Second, be sure the counseling methods they employ line up with God's truth as revealed in scripture. My father was a Freudian psychologist, and his methods left me filled with despair. I tell folks all the time that God brought me

through supernatural cognitive behavioral therapy as He taught me to "take every thought captive to the obedience of Christ" (2 Cor. 10:5). Living through abuse warps our thinking, so methods that focus on renewing our minds are most effective. Applying His Word and promises as a standard is powerful.

Finally, I think I should mention that this book contains accounts of experiences that could possibly be triggers for those struggling with PTSD. I considered leaving some of these stories out, but in the end I felt it was important to share them in order to give readers (especially those unfamiliar with the dynamics of abuse) a more accurate picture of the malicious nature of domestic violence. Being able to see the truth clearly, even when it's ugly, is important. While I personally know how unpleasant triggers can be, I don't believe that avoiding them indefinitely is the solution. In our support groups, we teach our ladies to use triggers as occasions to reprogram the faulty thinking patterns their abusers have instilled in them.

Typically, behind fear and panic, we find untrue beliefs heightening the problem. Identifying deceptive thoughts and replacing them with truth is key to moving forward. However, this needs to happen slowly, as God gives grace. So if you find yourself overcome by emotion while you are reading, take frequent breaks. If you are worried about triggers, skip ahead to Chapter 12 on "Managing Your Emotions." Choose to apply truth to

the negative thoughts that consume you, and continue to read gradually. In counseling, I often ask counselees to identify and write down the thoughts that accompany their overwhelming negative emotions and then examine them in the light of scripture. If it's an irrational fear, apply a scripture that counters the fear. Say the passage *out loud* as often as the thought surfaces, and claim His promises. There is a database of helpful scriptures at the end of the book to help you get started. Another solution for overcoming fear is worship. When I was coming out of abuse, I kept praise and worship music playing continually. I sang out loud when I felt especially overwhelmed. *There is nothing more powerful than making Him bigger than your problems.* Give Him your fears and your heart. He is entirely trustworthy and able to move you from victim to victor.

Foreword by Chris Moles

I belong to a small tribe—or at least at the time of this writing it is small. We have hope that more will join the cause. There is a small but growing number of Christians who are engaged in the work of domestic violence prevention and intervention. As I became more committed to writing and speaking on the topic of domestic violence from a pastoral perspective, it wasn't long before others in the movement began to reach out to me. Among the most memorable was Joy Forrest. A survivor herself, she passionately advocates for others through a growing local ministry to victims and families. In addition to the common aspects of our work, Joy and I also hold similar graduate degrees in Biblical Counseling which means we shared something far more significant: a love for and commitment to the Sufficiency of Scripture. So when she asked me to read *Called to Peace*, I knew I was not only going to interact with her story and her knowledge, but also with the life-changing truth of the Scripture.

Called to Peace is a story, but it is also so much more. This book will illustrate how faith, family, and fear shaped the experiences of one victim of domestic violence. You will learn many of the tactics commonly used by abusers as you meet "Doug," a charming and seemingly caring partner who at first used subtle tactics to groom his victim. Over time, his actions morphed into overt acts of coercive control. You will also gain tremendous insight

into the life of a victim. Expect to see beyond just the incidents of abuse as Joy recounts the confusion, longings, and attempts to "fix" the problems in her relationship. The most pressing lesson from Joy's story, in my opinion, is that God cared for Joy and, in fact, He cares for all victims. He cares far more about the hurting, the oppressed, and the battered than our sometimes misdirected adherence to principles of headship, submission, and suffering. Joy's story is the story of a survivor of domestic violence, but it is also the story of God's faithfulness and of the power and sufficiency of His word.

If you are a *victim*, please find hope in these pages. While your story will not be the same as Joy's story, the God within this story is unchanging. Yes, find comfort in knowing that you are not alone. Embrace the hope of the gospel: you are loved, and you are pursued by a savior who has conquered evil.

If you are a *people helper*, please find insight into the families with whom you will interact. Perhaps some of the clients, counselees, and neighbors you interact with are experiencing the weight of domestic abuse. Glean what you can from this work as you pursue peace in your context.

If you are a *pastor*, prepare to be challenged. We are often the first people women turn to for help, but we tend to be the least helpful. Joy's words may sting or challenge your assumptions. Please, as a fellow pastor, I

ask you to read this work with an open heart and an open Bible. You may be surprised with what you find.

Called to Peace is a textbook. Throughout the book, you will interact with the truth regarding the nature of domestic abuse. Some sections of the book will also introduce concepts, terminology, and strategies for addressing the abuse. If the story brings the realities of abuse to life, the teaching portions bring a practicality that is necessary to respond, whether you are a victim or a helper.

Called to Peace is a treasure. In the book, when Joy describes the moment she said goodbye to her earthly treasures, I was reminded of Joseph's words in Genesis 50:20, "What you meant for evil, God used for good." I wish this story were not true, but I am glad to say that we have it. God has taken a truly evil account and redeemed it for good. My prayer is that you will hear God's "call to peace" through this work and, who knows, maybe our little tribe will welcome one more to the cause.

Peace,

Rev. Chris Moles

Author of *The Heart of Domestic Abuse: Gospel Solutions for Men Who Use Control and Violence in the Home*

Introduction

My pastor looked at me apologetically as he handed me the business card for a local divorce attorney. His explanation caused an explosion of despair and anger in my heart. "I'm sorry, but I think this is your only option. I've tried everything I know, but things only seem to be getting worse."

I could not believe this man I'd reached out to for help was giving up and, even worse, was encouraging me to do the same. All I could think was, *Doesn't he know that God hates divorce, and that nothing is impossible for God? How can he just wash his hands of the situation and give me a worldly solution?* I was too shocked to even respond, but I decided then and there that I would seek help elsewhere. Over the months that followed, I exhausted every resource I could find, but the violence only grew deadlier. Ultimately, I was forced to come to the same sad conclusion as my pastor.

After finally leaving my abusive marriage, I began to realize how warped my thinking had become. Over time, I had become so rigid in my beliefs that my view of God had actually worked against me. Although I never would have voiced it, as I was and still am a conservative Christian, deep down I thought God cared more about my marriage than my life. Besides my own faulty thinking, my husband often quoted scripture to remind me that he was the head of our house. As I look

back at myself during that time, I'm almost embarrassed to share this story. Those who have never lived with abuse will probably read this and shake their heads at the absurdity of my decisions. However, in the twenty-one years that I have been out of abuse, I have worked with scores of domestic violence survivors and have found that many of them have struggled with the same sort of thinking. For me, the healing process required a complete overhaul in my thinking, and the same is true for nearly everyone coming out of abuse.

If you are currently in or have been in an abusive relationship, this book is especially for you. It is also for those who wish to help you. There are numerous resources for those who want to learn more about the dynamics of domestic abuse and how to get safe.[1] There are also resources that can help you learn to respond wisely to abusive people and to help break the cycle of abuse.[2] However, my goal with this book is not to address those issues. Neither is it my intention to debate whether or not abusive relationships can be saved.[3] My

[1] The National Coalition Against Domestic Violence has numerous resources for anyone wanting to learn more about the dynamics of domestic violence, making safety plans, etc. Visit www.ncdav.org. For faith-based resources go to http://www.focusministries1.org.

[2] For more on building your strength in destructive relationships, see Leslie Vernick's books *The Emotionally Destructive Relationship* and *The Emotionally Destructive Marriage.*

[3] For the record, I do believe these relationships can be saved. To believe otherwise would be contrary to the gospel. However, unless counselors and pastors who are helping have very specific training on the dynamics of abuse, it is highly unlikely. Chris Moles' book *The*

prayer is that this book will help you heal spiritually and emotionally, and help you see that God's heart is for you, regardless of what people tell you. His heart is always for the oppressed, and He holds the keys to your healing. Our Redeemer can turn your ashes into beauty. He loves you with an everlasting love and calls you from violence to peace.

Heart of Domestic Abuse is a great resource for those wanting to learn more about working with abusive men.

Part One

A Story of Abuse

My companion attacks his friend; he violates his covenant.
his talk is smooth as butter, yet war is in his heart;
his words are more soothing than oil, yet they are drawn
swords.
Cast your cares on the LORD and he will sustain you;
he will never let the righteous be shaken.
— Psalm 55:20–22

Chapter 1
A Fragile Foundation

Unless the Lord builds the house, the builders labor in
vain.
– Psalm 127:1a

I did not grow up with abuse. As a matter of fact, in
my family, I never even heard harsh words or raised
voices. In my early years, my father was a pastor. His
theological training questioned the authority of scripture
and suggested that God was uninvolved in the affairs of
people. Like most children, I admired my dad and
naturally absorbed his beliefs. His teachings led me to
believe Jesus's sole purpose on earth was to challenge
injustice, while His redemptive work on the cross was
never explained to me. I very much appreciate the brave
stand my parents took against racism in the midst of a
small, southern town in the 1960s. My dad eventually
preached a sermon in favor of civil rights one Sunday

3

and, almost immediately, the backlash began. Within days, Klansmen in our congregation had burned a cross in the churchyard, and Daddy was pretty much forced to resign.

After leaving the ministry, Daddy went into psychology, but his change in vocation was more like a change in religion as he traded postmodern theology for the futility of Freudian psychology. As soon as he helped us find a church, he stopped attending. In the meantime, we were introduced to a new concept—the family meeting. Daddy would bring up a problem issue and then encourage us to express our feelings on the subject. The whole point seemed to be emotional venting rather than actually finding solutions. It never made much sense to me and never appeared to accomplish anything. As I visited my father at work, I learned that our family meetings mirrored group therapy. I guess those meetings were his attempts to help his family; however, they simply deepened my already growing sense of despair.

Both of the ideologies I had learned from my father rejected absolute truth, and I became an extremely confused and empty teenager. I was angry about the way the church had treated my dad, so Christianity didn't seem to be an option for me. Eventually, I became a hippie and began to search elsewhere for answers, studying everything from Buddhism to New Age. I even ended up practicing witchcraft and the occult. As I began to spin out of control, my parents' marriage began to teeter on the verge of collapse. I chose to escape the

unspoken strain by running away from home. My dad stopped everything to find his runaway daughter. When he found me two weeks later, I was numb from drugs and angry that I had to return home. I certainly didn't care about the pain I had caused my parents. However, my drastic action caused an equally drastic reaction on their part. I was reeled in and introduced to discipline unlike any I had ever known. I was grounded and only allowed to go to school and church. Within a few months, I went off to summer camp. The pastor of our church gave me a copy of the New Testament. Although I believed in Jesus, I had never really understood that the God of the universe wanted to have a personal relationship with me. My sinful path had left me empty and miserable, but by the end of that week at summer camp, I had surrendered my life to Jesus. The change was dramatic. I was a new person and the emptiness was gone.

In spite of the obvious change in my life, my parents continued to grow apart. My mother eventually returned to the faith of her youth, but Daddy held on to his faith in empty philosophies. One day during my junior year of high school, he called a family meeting and politely announced his intention to leave our family. My mother and younger sister remained calm, but I was devastated. And even though he assured us that we would see him regularly, his visits became more and more sporadic. By the time I reached my sophomore year in college, I had not seen or heard from my father in over a year. The father I had so deeply admired as a

child seemed to have rejected me completely.[4] I found comfort from my Heavenly Father, but still, my parents' divorce profoundly affected me.

[4] While there's no room for it in this account, I do not want to let the last mention of my father here be a negative one. My dad eventually came back to God and we were reconciled. He passed away six years before I finally left Doug for good, but I know he saw the signs of abuse before anyone else did because he often tried to warn me.

Chapter 2
Becoming a Victim

Do not make friends with a hot-tempered person, do not associate with one easily angered, or you may learn their ways and get yourself ensnared.
– Proverbs 22:24–25

During my tumultuous high school years, I met a young man three years my senior. He was handsome and charming. Frankly, I was surprised that he even took an interest in me. Even more amazing was the fact that he seemed to care about every little detail of my life. He called me often and usually knew where I was and what I was doing at any given time of day. I thought, surely, this kind of attention represented real love. As a middle child in a family of four children, I was unaccustomed to being the object of so much attention and found it extremely flattering.

One day, after a few months of dating "Doug," he

began asking questions about my past. He did not like my answers about prior boyfriends and blew up at me with a fury unlike anything I had ever experienced. We were driving at the time, so he slammed on the brakes and ordered me out of the car nearly five miles from my home. I quickly obeyed his command and he drove off. He soon returned, ordered me back into the car, and drove me home without a word. The whole incident was quite confusing, and I really couldn't figure out why he had become so angry. However, I assumed I must have deserved it. He did not call for several days, but when he finally did, he apologized, explained how I had hurt him, and said that he just couldn't handle it. He seemed so sincere that I actually felt sorry for him and was sorry I had caused him such trauma. Thus ended lesson number one in a relationship that eventually distorted my thinking and nearly cost me my life.

While nothing I did could affect the father who raised me, everything I did affected Doug. I became even more convinced that he must really love me because I had the power to hurt and upset him so deeply. I also began to believe that he truly could not help himself when he blew up. I felt sorry for him because he'd had such a hard life. It seemed he had always been the victim somewhere. I thought he needed me, and I also thought that if I left, he might completely fall apart.

Doug and I dated for eight years before we got married. During that time, I got used to the ups and downs. We had some very good times, but I never knew

when something minor might set him off. He either treated me like a princess or like a slave. Just when I would begin to get fed up enough to leave, the sweet temperament I had fallen in love with would return. Over the years, I learned to "tip-toe" in order to avoid his explosions. Yet there were times when I was blindsided by them. I couldn't always predict what might set him off. It could be as simple as a lost item or my choice in clothing, but it could also be related to his erroneous interpretation of my thoughts or motives.

One day, we were enjoying a pleasant meal when suddenly Doug's demeanor changed. I could tell he was angry, but for the life of me couldn't figure out why. After we left the restaurant, I asked him what was wrong. He just glared at me, inferring that I must know the reason. I knew I had done nothing wrong, so I continued to press him until he finally told me what was bothering him. Apparently, he thought I was staring at a man across the restaurant, but I had never even noticed the man he described. Throughout our eight years of dating, there were numerous situations of extreme jealousy. Even though our relationship was emotionally painful at times, I told myself that leaving meant I would be wasting all the years I'd been with him. Besides, Doug had never physically harmed me. He had seen his father abuse his mother and had hated it with a passion, so I figured I would never have to worry about that.

The bottom line was that I made excuse after excuse to justify staying in a relationship that was in no way

honoring God. The worst part of it all was that Doug became the center of my universe, and God took second place in my life. As a result, the focus of my life was trying to please a man who constantly changed his demands. Regardless of my spiritual compromise, I prayed for the Lord to bless our relationship and believed He would certainly answer my prayers. After all, we both claimed His name. During a period of backsliding and severe depression on my part, Doug and I married. I made an attempt to return to God and asked Him to bless our marriage, but I had no peace about it.

Chapter 3
Perishing

*Be gracious to me O God, for man tramples on me; all day
long an attacker oppresses me...*
– Psalm 56:1 (ESV)

There was never a honeymoon stage in our marriage. Within a month of the wedding, Doug's behavior became increasingly unbearable. One weekend my brother came to visit us. He went to bed, leaving his socks on the floor and an apple core on the table. I had gone to bed earlier, but Doug was still awake. Around 3:00 a.m., he came into the room, turned on the overhead lights, and yanked the covers off of me.

He got right in my face and angrily hissed, "Get in there and clean up your brother's mess!"

I was hardly coherent but was completely stunned that something so minor would upset him this much. While I had already learned to be careful about what I

said and did around Doug, this experience added a whole new dimension of fear for me. The anger I saw in his eyes that night seemed dangerous, and I felt that if I didn't obey him, he would have physically hurt me.

Doug had graduated from college a month before our wedding but was unable to find a steady job during the first two years of our marriage. Somewhere along the line, he'd read a book by a famous faith teacher that gave him the impression that God was bound to answer any of his prayers as long as he had enough faith. Doug thought he could believe himself into any job he wanted and refused to take anything less than the best. When he was still unemployed a month later, he began to blame God, and his temper seemed to worsen daily. Shortly afterwards, we both were accepted into master's degree programs at a nearby university and his anger subsided briefly. However, by the end of the first semester, he expressed he was having some problems in his program. When I prompted him further, he said he simply had a personality conflict with the director of the program. As a result, Doug ended up leaving school. I had taken to my program quite well, though, and remained in it. Unfortunately, Doug was upset with my success.

As Doug's problems in school increased, so did his rage at home. The verbal abuse was horrendous. I had never heard such language and had never felt so hated. There were times when he would scream at me into the early hours of the morning, refusing to let me sleep or study. He belittled me, called me names, and inferred

that I was stupid and worthless. He would block the exit to a room and basically hold me hostage as the verbal assault continued. During these rampages, he often threw things, punched the walls, or destroyed my property, and I truly feared for my safety. According to Doug, all of his problems were my fault, even though I'd tried everything I could to encourage him and to let him know that I wanted only the best for him. Unfortunately, his perspective on life was warped, and he did not trust anyone, especially not me. It seemed as though he couldn't believe that anyone could actually love him unconditionally. No matter what I did or said, he judged my motives as evil. In my own heart, hopelessness and despair began to set in and, deep inside, I found myself disappointed with God. Although I had never prayed for His will before entering into marriage, I did expect Him to make it work. I thought surely He would be bound to bless the covenant we had made before Him and work out all the kinks. I found that, contrary to my expectations and regardless of my prayers, the problems only amplified as time passed.

Over time, I began to dread leaving my friends at school and entering my dreary, lifeless home. I was free to be myself at school; at home I could show no joy. If I showed any happiness, Doug's misery was thrown in my face. How dare I be happy when he was so miserable? Every conversation was focused on him, and I did my best to encourage him. However, Doug said I had no right to try and cheer him up since I had no idea of what his life was like. Most attempts to support him

ended with him referring to me as a naïve idiot. He criticized me so much that I was convinced he couldn't really love me.

Although Doug had never physically hurt me, the angry outbursts at home continued to worsen until I felt I could no longer bear it. I shared my predicament with a friend at work who encouraged me to leave Doug. This support gave me hope, and I began to plan my escape. My newfound hope must have caused my demeanor to change because Doug seemed to suspect I was planning to leave. One night, he began to press me for information. He asked if I was planning on leaving, or if I wanted out of the marriage. I was terrified but did not want to lie. I told him we didn't have a real marriage and that I was miserable. He flipped out, and suddenly I found myself up against a wall as he kicked my abdomen repeatedly. I do not remember how I got through that night, but I do know that the next day I packed up and left. The verbal cruelty I had endured for eleven years had finally become physical. We did not have a car, so a friend drove me to my mother's house about twenty miles away. Doug ended up spending a night in jail for communicating a threat to my friend, but his parents came the following day, bailed him out, and took him back to their home a few hours away.

At first I was terrified that Doug would come back and hurt me, so another friend offered me lodging in her apartment. I wasted no time in getting a formal separation that included a protective order. My stomach seemed to be doing flip-flops and I was nauseated daily.

A few weeks later, I discovered my stomach issues were not merely from nerves, but that I was pregnant. This caused me to do a lot of soul searching, and also led me to repent for my own perceived selfishness and worldliness. How sobering it was to think I was going to be responsible for another life when I couldn't even handle my own. I was completely broken before God. I felt a profound sense of sorrow. I had strayed from His path and wanted to get back on it. I began to wonder if I had given up on my marriage too soon.

I faced the beginning of my pregnancy alone. Financially, things were bleak. I had a part-time job and financial aid, but these were, at best, temporary and insufficient means of income. Worst of all, I had no health insurance. It was a rather scary place to be in life, and there were no easy answers. In the meantime, I stayed in touch with my sister-in-law. She was a good friend and kept me informed about Doug. It seemed, contrary to his picky nature, he had taken a low-wage job and was going to church on a regular basis. He was even counseling with the pastor there, so I began to find hope for reconciliation. Sometime in my second trimester of pregnancy, I got up the nerve to pick up the phone and call him. When I told him I was pregnant, he began to cry. After asking if the baby was his, he told me that it was an answer to his prayers. He regretted our separation and was longing for a family. I told him I was also grieved over the loss of our marriage, but was afraid of what he might do to me if we reconciled.

Over the next few weeks, Doug did everything in his

power to win me back. I thought I saw an overall improvement in his temperament. Since the prospect of being a single mom did not appeal to me, I decided to ignore any remaining doubts I had about safety and consented to a reconciliation. Within weeks of our reunion, the fear was back. During my seventh month of pregnancy, Doug went into a rage while driving. We were in a downtown area when he began to speed through red lights, weave in and out of lanes, and dodge cars. I was sure we were going to die and begged him to slow down. After numerous pleas, he finally screeched to a halt. I knew then that there had been no real change in him. He had only put on an act to get his way.

During the final stages of my pregnancy, I had to stop working and depended on Doug for financial support. He had finally gotten a decent job with health insurance and, luckily, that seemed to help his attitude around the house. Every time there was a lapse in the anger, this man and my dream of an ideal marriage became the center of my universe. I continued to believe that God would heal us, and my child would be raised in a wonderful Christian home.

My daughter Haley was born via emergency C-section after twenty-seven hours of labor. Her heart rate showed she was in distress, so there was no other option. Doug got angry with my doctor, called her incompetent, and then stormed out. I went into surgery not having any idea of where he was.

Chapter 4
Hope Deferred

*Hope deferred makes the heart sick, but a longing fulfilled
is a tree of life.*
— Proverbs 13:12

My dreams of a Christian family never materialized.
Doug soon lost his job and became increasingly bitter.
He reminded me of the book he had read a few years
earlier, stating that God would answer any prayer
uttered in faith. He had prayed and believed for a new
job, but nothing had happened. Since the faith teachers
guaranteed he could pray for and receive any job he
wanted, he decided that God was nothing but a liar who
played favorites. He also thought that since I seemed to
have better luck with jobs and schooling, I was clearly
one of God's favorites.

Doug saw himself as a miserable victim of
circumstances and felt that God was responsible for his

misery. His response was to turn his back on God and to order me to quit going to church. He also insisted I give up my faith because my support of God meant I was taking His side over him. Even though I tried to encourage him and assure him that both God and I were on his side, he could not be persuaded. Violence soon became a regular occurrence in our home. On one occasion, Doug held a pocketknife to my throat and demanded me to deny God, saying that if I didn't, he would send me to meet Him. We struggled until I was able to break free and run next door. The next-door neighbors in our townhouse apartment couldn't help but hear what had been happening. They were Christians, and they tried to encourage me to leave, but I merely rejected their advice as unbiblical.

The morning after the knife incident was a Sunday. As the baby and I were leaving for church, Doug came running out of the house and ordered me back inside. He reached into my car, grabbed my Bible, tried to tear it apart, and then threw it to the ground and stomped on it. I was afraid I would be next, so I drove off. He followed on foot until I could get past the speed bumps in our apartment complex and gain enough speed to escape him. At church that morning, I was completely overwhelmed and confused as I poured my heart out to the Lord. As a young Christian, I had attended a rather conservative church that taught women were to submit to their husbands in every circumstance. This created a real struggle within my spirit. After the service, I told our pastor and his wife what had happened the night

before, and I asked for prayer. I explained that I knew I was supposed to submit, but I was very afraid to go home.

Pastor Rick calmly listened and simply stated, "The Bible says to submit as is fitting in the Lord, and this isn't fitting!"

I was shocked he didn't try to send me home to that angry man. Based on my understanding (or misunderstanding) of scripture, I thought the Lord wanted me to submit, regardless of the situation. How amazing it was to catch a glimpse of His amazing grace. Through my pastor's simple statement, I understood that my Heavenly Father cared more about me than my submission. Tears began to flow as I was reintroduced to His marvelous love. It was that love that had drawn me in the first place, but over the years, it had become obscured as fear of man had replaced my worship of Him.

For the next few years, Doug and I separated and reunited numerous times. Each time I left, Doug would eventually calm down and even seem repentant. He went to great lengths to win me back and said all the right things in counseling. We tried numerous counselors—pastors, Christian counselors, and secular mental health professionals. In most cases, the focus of counseling became my behavior and what I could do to stop making Doug so angry. After all, why would anyone be angry without being provoked? One psychiatrist suggested Doug had the lowest self-esteem of anyone he had ever seen and thought I should do

everything I could to boost his self-worth. His advice was not contrary to what I was already doing. In an effort to keep things from getting out of hand, I usually did everything in my power to encourage and build Doug up, but my attempts were met with very little success. The doctor's prescription had already failed before he'd even prescribed it to us.

Regardless of my positive attitude, the violence always returned. It was like a roller-coaster ride—a never-ending cycle that seemed impossible to break. Finally, somebody gave me a copy of *Love Must Be Tough* by James Dobson. This book opened my eyes to a whole new concept. Perhaps rolling over and taking the abuse wasn't the most loving thing I could do. I was fed up with the violence and determined to take a strong stand against it. Eventually, Doug learned that any aggression on his part would result in a call to the police on my part, and I began to see some positive changes, although he never seemed very happy.

In his never-ending search for significance, Doug decided to apply for medical school. We drove to West Virginia and Pennsylvania for interviews, but he came back convinced he would never be accepted. However, both schools offered him a spot. Just before we were ready to move, I found out I was pregnant again. Doug thought this meant he would not be able to attend medical school since I would have to be the main breadwinner. As it turned out, we were able to go anyway because his father offered us financial assistance. Our second daughter, Hannah, was born just

after Doug's first semester of school. This time I had elected to have a scheduled C-section. At the time, he was angry with his school—convinced he had flunked the first semester—so he sat in the operating room as the doctor was doing the surgery and made critical remarks about the school the whole time. It was awful; I felt exposed in every way possible. After Hannah was born, it turned out that Doug's negative predictions were wrong, and by the second year of school, life seemed to improve.

Although things were stressful for me with a full-time job and two small children, it seemed the violence had become a distant memory. Doug was finally realizing his lifelong goal of becoming a doctor, and this seemed to improve his disposition somewhat. There was no real joy in our relationship, but his concentration on school and his fear of negative consequences helped to maintain the peace. I also believe that my role as the main wage earner helped Doug to control his temper. He seemed to try to avoid upsetting me too much for fear I would quit my job or leave, in which case he would lose his source of income. As a result, those four years were the most stable years our marriage ever knew.

Chapter 5
Vicious Cycle

A hot-tempered person must pay the penalty; rescue them,
and you will have to do it again.
– Proverbs 19:19

Perhaps the four years of relative quiet lulled me back into complacency. I seemed to have forgotten how taking a firm stand had finally stopped the violence before. After Doug graduated from medical school, our stability quickly became a memory. We moved from Philadelphia to Atlanta, and I decided to try staying home with the children for a while. I felt like I had missed so much of their lives by working full time while Doug was in school. This decision was vitally important to me, and I believed any financial sacrifice was worth it. Perhaps that decision also played into my increased willingness to tolerate more and more questionable behavior from Doug. Working untold hours as an intern, along with the pressure of having the full responsibility

for our financial well-being, seemed to weigh heavily on him.

As we became acquainted with the extremely difficult life of a medical intern, we became reacquainted with our old relationship patterns. Doug would become stressed out about something that happened at work, then come home and take his frustration out on the children and me. Although he didn't physically harm us, his fits of rage were terrifying. Several times, I had to take the children and leave the house until he calmed down. One time, we had to stay in a hotel for two days to escape his wrath. The third day, our credit card reached its limit, and we had to return home even though Doug was still quite angry. Fortunately, his long hours at the hospital kept him away for another day or so and tired him out enough to prevent another crisis once he came home.

While things were back to "normal" on the home front, things did not go so smoothly for Doug at work. One day he overreacted to a scheduling change and threw a lamp. He was immediately suspended from work, without pay, and was forced to seek a psychiatric evaluation. He was required to complete any prescribed treatment prior to returning to work. During his suspension, I called the chief of the residency program and tried to explain Doug's behavior while begging for leniency. I explained that our family was dependent on Doug's income and that he was probably suffering from a lack of sleep when he threw the lamp. As had become my habit, I took responsibility for his life and did my

best to clean up his mess. My efforts were met with success as I was able to convince the chief to bring him back earlier than the original suspension required.

For the two to three weeks Doug was home during his suspension, things went quite well. He actually started attending church and praying with me. It seemed that a crisis always brought him to his knees. However, it appeared that even as Doug was seeking the Lord, he was also seeking to maintain a degree of control in the midst of calamity. He didn't like the diagnosis of the first psychiatrist he had seen and eventually settled on a counselor from a prominent Christian counseling center. I even went with him to present his case to the counselor because I was just as determined as Doug was to present a sanitized version of our problems. As a result of our efforts, the counselor simply prescribed a course of anger management for Doug. This allowed him to return to work and, within a few months, the counselor sent the hospital a letter stating Doug had successfully completed the anger management therapy—as if to say he was fixed. I chose to believe the counselor's diagnosis because the truth was too painful to accept.

In the years that followed, lies and denial continued to be our standard. I went with Doug to his counseling sessions from time to time and found that he rarely told the counselors the truth. But I was afraid to call his bluff, so I sat silent and let the deception flow. I knew I would surely face his anger at home if I said anything, and I guess I knew that exposing his

dishonesty would also shine a light on my own unhealthy condition. After all, I had supported him and smoothed his path for years. How stupid would it make me look if people knew the real story? As Doug finished his training years, our social standing in the community improved, making the thought of exposure even more dreadful to me. We moved to a small town in Virginia and portrayed the all-American family to the community. To use Jesus's analogy, our family was nothing more than a whitewashed tomb: beautiful on the outside, but dark, dank, and rotten on the inside. However, we serve a Lord who is a specialist at rolling away tombstones, and His light would soon shine into our darkness.

Chapter 6
The Tempest

I said, "Oh that I had the wings of a dove! I would fly away and be at rest... I would hurry to my place of shelter, far from the tempest and storm."
– Psalm 55:6 & 8

While I made every effort to conceal the true nature of our family to the world, I continued to cry out to God for healing. My heart longed for an easy answer, but my Great Physician knew surgery would be required. He gently began to prepare me for the pain that was to come. I found a few like-minded homeschooling moms and together we started a ladies' Bible study group shortly after my arrival in Virginia. My dear friend Susan had been involved in several of Kay Arthur's Precepts Bible studies in Florida and suggested that we start with one of Kay's Lord Series books. The title chosen was *Lord, Where Are You When Bad Things Happen?* One of the members of our group expressed a

reluctance to do the study. She said God always used her studies to prepare her for life circumstances and she was not in the mood to be prepared for tragedy. I just laughed at her and proceeded to sign up for the class.

I had been a Christian for over twenty years and was finally about to learn how to really study the Bible. Our study of the book of Habakkuk focused on the sovereignty of God. The idea that God would use bad situations for good was not new to me. However, the thought that He was in control even during the worst of circumstances was something I had never really pondered. In the videos, which accompanied the book, I remember Kay Arthur speaking of bad circumstances as being "sifted through His fingers of love." She gave examples of horrific tragedy and demonstrated God's goodness in the midst of those situations. In my mind, I had always seen evil as from Satan and good from God, but never considered that evil circumstances could actually be used for His purposes. I was about to have this lesson reinforced through experience. Within a year of completing this study, my world would change completely.

Toward the end of his residency, Doug discovered he could make incredible amounts of money by moonlighting in community hospital ERs on the weekends. Suddenly, our money problems were a thing of the past. But as money became abundant, our time together became scarce. Doug worked back-to-back shifts so often that he did not make it home most weekends. Even after he finished his residency and

began his first job as a staff physician at a hospital fifty miles away, he continued to moonlight on weekends. At times, he worked 14-hour shifts at his new job and would just spend the night at the hospital to avoid two hours of travel time back and forth. When he did come home during the week, he was tired and irritable. Frankly, it got to the point where I was relieved to see him go back to work most of the time. His temper seemed to be getting worse and worse. Violence subtly began to creep back into our marriage.

One day Doug came home in a particularly bad mood. I was homeschooling Haley at the time, and he decided I wasn't doing a very good job. He asked her how to spell a word, and she misspelled it. That sent him over the edge. He then asked her how to spell "belt" and threatened that if she didn't get it right, he would spank her with his belt. Haley became so afraid that she clammed up, and he began to scream even louder. When I tried to calm him down, he grabbed my arm and attempted to throw me down our basement stairs. I sat down and resisted as hard as I could, but we struggled for quite a while.

After this incident, I took the kids and left the house for a few days. Things soon calmed down, though, and we again returned home. There were several months of relative calm, but as usual, the holidays added stress which led to problems. That Christmas Haley had asked for a guitar, but I had not been able to find one that fit the budget I was given, so I got her a keyboard instead. It was obvious from her

facial expression that she was disappointed, but she didn't vocalize it. Doug was furious when he saw her face. He told her that if she didn't like what she got, she could just say goodbye to all her Christmas presents. He went to the kitchen, got a large trash bag, and proceeded to throw all of her presents into the bag, all the while saying, "No Christmas for you this year!" She begged and pleaded for him to stop, but he pulled her hair, pushed her toward the stairs, and told her to go to her room. Hannah and I were so afraid that we went with her into her room and locked the door.

That was the first time he had actually crossed the line of violence with one of the children. I wanted to run as far away as I could. We sat on Haley's bed crying. Her response hurt just as badly as his outburst.

"Why does *he* have to be my dad?" she asked.

What was happening to my children? When the violence was directed at me, I could handle it, but this was a whole new level of pain. I would have left that day, but we had his family coming in from out of town, so we waited upstairs for a few hours until he calmed down. Then, we did what we had learned to do so well; we continued the day as though nothing had ever happened. Haley even got her gifts back. His anger was gone and the day ended pleasantly. It seemed ridiculous to leave on Christmas after things had turned around so nicely.

Over time, our never-ending cycle became a downward spiral. I was so weary and begged the Lord for relief. The events in the months after the Christmas

episode gave me more courage to confront the truth, regardless of my fear of Doug. As I prayed, I began to realize that Doug was rarely honest with me, and I couldn't live with lies any longer. Each time I would confront him about things, he managed to turn everything back on me and make me believe I was imagining things. He had always been a great actor and, in addition to acting completely innocent, he made me think I was crazy for ever doubting him. However, I had been keeping a journal over the years, and as I read it, I began to recognize the pattern of his lies. I could not let it rest any longer. Still, I wanted to do things God's way and confessed my own sins, even as I confronted his.

Admitting to my own sin did nothing to encourage repentance in Doug. Instead he knocked me to the floor in front of the girls and then left me there. After leaving the room, he began ravaging the house and throwing things. I heard a loud bang in the kitchen, which I later learned was our brand-new microwave hitting the floor. I knew time was short before his return and reached for the phone. Too embarrassed to have the police show up, I called the home of a dear couple from my church. They had given us refuge earlier that year when Doug had blown up. Ellis didn't even recognize my voice because I was so upset. I explained the situation to him, and he got into his car to come get us. I gathered the girls and my purse and then ran outside to wait. Doug was still upstairs tearing things up, so we were able to get away.

Doug did not know where my friends lived, but he did know their phone number and used it regularly that

night, even though they never told him we were there. The next day, I decided we needed to go back to the house and get some things because we had left with nothing but the clothes on our backs and my purse. My friend Ellis was bigger than Doug, so he came with me. As we entered the house, we noticed Doug had an ax sitting on the couch. He quickly grabbed my purse and cleared out all my bank cards. Ellis tried to convince him to be reasonable and let me get some things, but Doug just picked up the ax. He told us to leave and filled our ears with profanity. As we left, Doug followed us outside waving the ax and cursing all the way. When we got into Ellis's van and started to back out of the driveway, Doug threw the ax at us. It was clear I would not be able to get any necessities from home anytime soon, so Ellis drove me to the bank. After some discussion with the teller, I was able to empty out half of our savings account.

Chapter 7
Light in the Darkness

The light shines in the darkness, and the darkness has not
overcome it.
– John 1:5

As we drove back to Ellis and Karen's house, I realized we would no longer be able to stay with them; Doug had threatened them too many times. One of the ladies from my Bible study came to the rescue and offered us refuge with her family. During my stay there, I spent much time in the Word and in prayer. The Lord was faithful in speaking to my aching heart. Two scriptures seemed to jump off the page and land straight into my heart. When I stumbled onto Jeremiah 29:11, in which God promises His children hope and a future, I knew it was God's word for me. Just before I found it, I had been crying out to God how life seemed hopeless and how I had no future. He also reminded me of the promise in Romans 8:28 that He would somehow use

what I was experiencing for good.

The day after the Lord showed me these scriptures, I went to visit my friend Dee. Her pastor's wife was there and Dee explained my plight to her. As she listened, she picked up her Bible and looked me straight in the eye.

She said, "I believe the Lord would have me share two scriptures with you."

The first was Jeremiah 29:11, and the second was Romans 8:28. Even in the darkest days of my life, our wonderful Lord reached down to confirm His great love for me, and He would continue to speak His words of comfort into my life. However, circumstances only continued to worsen.

One morning I woke with Jesus's words on my mind: "Lay not up for yourselves treasures upon the earth, where moth and rust consume, and where thieves break through and steal, but lay up for yourselves treasures in heaven…" (Mt. 6:19). Deep inside, I knew I was about to lose most of my earthly treasures. Doug had destroyed some of my clothes the first time we separated, and I believed this time he would do worse. It wasn't long before that belief was confirmed. I had inherited many beautiful antiques from my grandmother, so Doug decided that if he couldn't get to me, he would destroy the things I loved. Still, the message from God was clear, and my heart was prepared. Soon afterward, I learned Doug had taken his ax to my beloved antiques.

My mother was the one who informed me of

Doug's destructive rampage. Not only had he chopped and burned furniture, he had also bagged up all of my clothes and personal belongings. He called my mom and told her he had destroyed many of our family heirlooms, and the rest of my stuff would be going into the dumpster if I didn't come home and "face my punishment." I contacted the police to try and stop the destruction. They asked many questions about how dangerous Doug might be, whether or not he owned a gun, and whether he might attack any officers who might visit the house. They told me there was nothing they could do to stop him from destroying the furniture. Even though I brought it into the marriage, it had become marital property, and as such, he could do whatever he wanted with it. In spite of their reluctance to deal with this issue, I was finally able to convince them to go talk to him. When the officers arrived at the house, they found him holding an ax and burning furniture. They couldn't convince him to stop the destruction, but they were able to get a key to one of our cars for me; however, they told me he had let the air out of all the tires.

The following day I learned Doug had taken many of my belongings to the town dumpster, so I decided to go and try to retrieve what was left of my things. Some ladies from my Bible study volunteered their husbands to accompany me. It was nearly dusk when I climbed down into the rubbish. I saw so many of my precious belongings strewn over mounds of garbage. He had poured ink over my most expensive clothes. Some items

were in trash bags, so I opened bags as I went and handed things up to the men outside. It seemed as if every personal item I owned was in that dumpster: jewelry, shoes, antique silver, houseplants, clothing, lamps, toiletries, makeup, curling irons, books and more books—even my Bible! Some trash bags contained my things, others just had garbage, so before long I was thigh deep in dirty diapers and rotten food.

Suddenly I heard shouting outside. Doug was back and yelling at the men helping me. He ordered them to stop taking my things out and told them he was burning all the furniture at home. It was getting dark outside, so I turned off my flashlight and prayed he would not see me. He didn't, but he began throwing items back into the dumpster. First, he threw a lamp which barely missed my head and then a large bag that knocked me over into the debris below. I just sat there and prayed until he left. As I stood up, I found myself saying, *Lord, nobody has ever been through this before! Nobody knows what I'm going through!* As soon as I uttered those words, something amazing happened. His supernatural peace flooded my soul. In my spirit, I could hear Somebody gently saying, *I have. I know.* God was with me, and everything on earth faded in His presence. There are no words that can adequately describe what happened to me that day as I had a revelation of His love unlike anything I had ever experienced. He knew the betrayal I was suffering. He had been betrayed by an intimate friend and was beaten and shamed by those He loved. Although I had known Him for over twenty years, I had

never experienced the depths of His love like I did in that moment. He had endured the cross because He knew sin would cause me to suffer, and He chose to share in my suffering. In the darkest moment of my life, His amazing light came shining through.

I often tell people that day was both the worst and best of my life because my eyes were opened wider to the depths of His great love for me. Paul's words seemed to sum up my feelings perfectly: "I count all things to be loss in view of the surpassing value of knowing Christ Jesus my Lord, for whom I have suffered the loss of all things, and count them but rubbish so that I may gain Christ" (Phil. 3:8). I would never have chosen the suffering I was experiencing, but Jesus chose to endure something far worse because of His great love for me. The thought was overwhelming. I stood in the dumpster and thanked Him for His amazing love, and I knew that a God who loved me that much would never let me go. I vowed I would not let go of Him either.

In the days following my experience at the dumpster, I tried to reach out to people for help in saving our marriage. I called our pastor to let him know what had happened, and he arranged to have us meet in his office for counseling. Apparently, he had already visited Doug and had gotten the story from him. According to Doug, I had caused him to "lose it." As faithful as I had been to our church, our pastor's tone indicated that he didn't think anyone would go that crazy unless they were provoked. Once again, it

appeared as though I was being considered as the source of Doug's anger. No matter how many times I explained that he was angry when I met him, the burden for his behavior always seemed to fall on me.

I got to the counseling session early and stayed close to the pastor. Doug's jaw was clenched tight as he sat and listened to the pastor tell us what he thought needed to happen in order for us to reconcile. Once the pastor finished speaking, Doug decided to give his take on the situation, as well as his prescription for saving the marriage. As far as he was concerned, I needed to get down on my knees and beg him to take me back. Doug also accused me of putting on a holy front before the pastor, and this angered me immensely because he always missed my true heart's motives. After years of living with a quick-tempered man, I had learned his ways and responded by showing the pastor just how unholy I could be with words. I let them both know, in no uncertain terms, that I really didn't care about what the pastor thought—I just wanted our marriage to work. In the meantime, Doug's insistence that I get down on my knees and beg for forgiveness intensified. He grabbed a large rock off of the pastor's bookshelf and raised it toward me, demanding an apology. The pastor quickly intervened, put the rock away, and the counseling session ended, having done more harm than good.

It was clear we were not going to find a peaceable solution to our problems. Doug continued to call friends and relatives in order to relay threats to me, and he

persisted in chopping and burning my grandmother's antiques. One day, while he was at work, I was able to get into the house and recover a few of the things he had not destroyed. He had not damaged the china cabinet yet, but he had begun to empty it. One of our outside garbage cans had been placed in the middle of the dining room floor. I looked inside to find it filled with broken china, glass, and many other family treasures. I took as many of the remaining items as I could from the cabinet and began to search for family photos. I was nervous and didn't want to stay long, so I was only able to find a few of our photo albums. It was hard to lose so much family history, but God's comfort was ever present in assuring me of greater treasures.

A few weeks after our first counseling experience, I tried to talk with my pastor about what could be done to save our marriage. He had made a few attempts to talk with Doug after that session in his office, but he decided our problems were beyond his abilities. He also suggested that separation and divorce were inevitable and gave me the card of a divorce attorney. I couldn't believe it; he was just giving up. It seemed like everyone thought nothing could be done, and nobody even tried to stop Doug's rampages—neither the police nor the church. It was devastating to me because I knew that nothing is impossible with God. Still, even though I wanted to restore our marriage, I knew my main priority had to be safety.

Doug's threats worsened daily. He did not know where the girls and I were, so he harassed friends and

family members incessantly. If they didn't take their phones off the hook, he would call them in the middle of the night to make threats and rant about my faults. It became unbearable to everyone involved, and I decided something had to be done. One of my friends was married to a deputy, so I sought his advice. He suggested I file a warrant and have Doug arrested for domestic assault, so I went up to the courthouse and filled out the paperwork. The magistrate was sympathetic and granted the warrant. However, it turned out to be more harmful than helpful. When the deputy tried to serve it, Doug was not home, so he just taped it to the door. The warrant simply stated that he needed to appear in court in a month which only increased his rage, and his threats intensified. I knew that if Doug ever found me, I would be severely injured or even killed. It wasn't long before I was faced with that possibility.

One Sunday morning, the girls and I got up early to attend a friend's church in Richmond. As we were driving home, I spotted Doug's car on the opposite side of the road. He recognized us and crossed the centerline into our path at about 60 mph. I slammed on the brakes and swerved off the road just in time to avoid a collision. Apparently, he was on his way to work and did not turn around to pursue us. The effect on the kids was the worst of it. They had seen the whole thing and were crying and screaming. Hannah had bumped her head and, with all the wisdom of a six-year-old, announced that daddies were not supposed to do such things to

their children. It broke my heart. I could endure his violence toward me, but seeing how he continued to hurt them was worse than anything he had ever done to me.

About a month after our separation, I was able to rent a small house about twenty minutes outside of town. I had been able to retrieve some of my remaining furniture from the house while Doug was at work. When we first moved in, Doug had no idea of our whereabouts, but within just a few months, our fragile security there was threatened too.

Through all of the turmoil, I had never given up on the idea of reconciliation. After all, my parents' divorce had caused me to believe that people who divorced just didn't try hard enough. Besides, God had miraculously changed my heart; surely He could redeem our marriage as well. After things had calmed down for a few months, I contacted Doug and asked him if he would be willing to go for counseling again. He wept and indicated a strong desire to save the marriage too. I decided not to tell him where we were living, and we went to counseling a few times.

I tried to proceed with caution, but my desire for reconciliation was greater than my ability to discern the truth. I confronted Doug and he seemed genuinely repentant. After a while, he convinced me the violence was a thing of the past and it was ridiculous to keep my address a secret. One day I let him follow me home, and it did not take long to realize I had made a grave mistake. At first he tried to convince me to move back

home with him, but when I told him I didn't feel comfortable with that, he began to make threats. He called me constantly and most conversations ended with one of us hanging up. I was afraid to keep the phone off the hook because I was sure it would provoke him to come out to the house. Often, I just held the phone from my ear and let him yell. Sometimes he would threaten to come out and kill us all. In those cases, I would load the girls into the car and head for a hotel. At times, I had to wake them in the middle of the night to flee, and since we lived in a small town, the only option was to drive an hour to get to a hotel.

One morning Doug showed up at the house and started pounding on the window of the side door with a nightstick. He ordered me to come out, but instead I dialed 911. I guess he was afraid the police were on the way because he merely yelled a few obscenities and then returned to his car. That wasn't the end of it though. He took his car, rammed the side of mine, backed up, and then rammed it two or three more times before he finally drove off. Miraculously, there was not a single dent in my car. I sat and waited for the police to come, but they never showed up. This pattern continued for several months until it became obvious that the law was not going to protect me. I grew tired of running and eventually borrowed a gun from a friend. However, I decided if I ever had to use it, I would not aim to kill.

The months following our initial separation were like a roller-coaster ride. Every time we had a month or two of calm, my intense hatred of divorce would kick in,

and I would reach out to Doug hoping for reconciliation—regardless of the fact that he had never shown me any evidence of true heart change. My own parents' divorce had hurt me so much, and I wanted to protect my children from the same hurt. However, Haley begged me to divorce him, saying if I didn't get away, he would surely kill me. Basically, my marriage had become an idol, and I was determined to work it out regardless of the ugly truth. Malachi 2:16, "God hates divorce," haunted me, and the idea of divorce was almost more painful than living with abuse, so I refused to give up.

Although I didn't believe divorce was an option, I did try to stay safe. One day I went to Doug's house to drop something off but decided not to get out of the car or go inside. He became angry when I told him I wasn't coming in and that I didn't see much hope for our relationship. He reached in the open window of my car, grabbed the hair on the back of my head, and began to pound my head against the steering wheel for what seemed like a couple of minutes. Haley was in the passenger's seat and reached over me to try to fight him off, scratching his neck in the process and leaving a long, deep gash. I suppose the pain finally caused him to let go. When I escaped, I found he had actually created a bald spot on my head, a knot on my forehead, and a few days later, I developed a noticeable black eye. That was a first. In the previous years, he always managed to kick or grab me in ways that left no visible bruises.

Chapter 8
Facing the Truth

Then you will know the truth, and the truth will set you free.
– John 8:32

After I received the black eye, things calmed down again. However, I was determined I would not get close to Doug again unless we could find some real help. As usual, he softened and seemed repentant, but I was too afraid to attempt reconciliation again. His kindness toward me continued for a few months, so I thought that maybe if I could find some expert on domestic violence, he'd be open to go for help. I asked him if he'd be willing to do anything it took to achieve reconciliation, and he said he would. In light of that, I called Focus on the Family, suggested they should do a show on domestic violence, and explained what was happening with us. They were quick to let me know they had

already done a few shows on the subject and graciously sent me the tapes free of charge.

When I listened to the Focus on the Family tapes, hope began to rise in my heart. Paul Hegstrom, founder of Life Skills International, was the guest. His program claimed a success rate of over 80 percent with abusive men, while general statistics quoted by other domestic violence (DV) programs indicated that only 3–5 percent of abusers ever overcome their abusive patterns. Paul also told his own personal story of abuse. As an active pastor, he regularly used to beat his wife, Judy, until the day he finally decided to leave her and the ministry. After they separated, he moved in with another woman and began to abuse her as well. One night he threw her down a flight of stairs, and the following day she had him arrested. Hegstrom lived in Minnesota, which, at the time, was one of the few states in the nation with domestic violence laws on the books. The only way for him to avoid jail time was to enter a program for abusers which placed him in a group of batterers who were all making excuses and rationalizing their behavior. Hegstrom said he was easily able to see just how ridiculous those excuses were because they were so familiar to him. Over time, he realized he was just as guilty as the other men in that group.

As this realization hit him, Paul spent a night in prayer before the Lord, asking Him to please change him. He felt hopeless after years of therapy and counseling and asked the Lord why he couldn't change. After a night of crying out to the Lord, Hegstrom said it

was if the still, small voice of God answered and told him the reason he had never changed was because he'd never had a teachable spirit. This was the turning point he needed. After that, he was determined to learn everything he could about DV and to be teachable. Eventually, he remarried his wife Judy and they founded Life Skills.

By the time I called Life Skills, Doug and I had been separated for nearly a year. I spoke to Judy and she told me there weren't any programs near us. The only thing they could suggest was an intensive week with an affiliated psychologist in Omaha. I convinced Doug to pay the $3,000 required, and we made the reservation. It was scary to have to get into a car and drive to the airport with Doug—even scarier to spend a week with him in a hotel in Omaha, but I was willing to give it one more try. The first day, we were taken into a training room with a video player and numerous Paul Hegstrom training tapes. We were also given various handouts on domestic violence, many coming from the Duluth, Minnesota project.

For the first time ever, we had found someone who understood us, and for the first time ever, I was told that I was not responsible for the abuse! I was amazed to find our situation was not uncommon and there was a whole body of research on DV. Abusers don't just suddenly go crazy, lose control, and start hitting. Rather, physical abuse is just part of an overall pattern of behaviors that perpetrators use to maintain control over their victims.

When I saw the Power and Control Wheel[5], I began to cry at the overwhelming reality before me. It was as if someone had been observing and taking notes for our entire marriage. Even before Doug delivered the first physical blow eleven years into our relationship, he had been using many of the control tactics on the Wheel since the day we met. By this twenty-third year of our relationship, I had experienced nearly every type of abuse shown on that chart. Over the years, his control of me had grown to the point where I filtered nearly every thought through his possible reaction. It was idolatry of the worst sort, and the resulting bondage was unbearable.

The first day at the Life Skills training was incredibly eye-opening. Over the years, in spite of all that had happened, I had never considered myself an abused wife. I just thought something had snapped in my husband. I thought some odd combination of events, along with his dysfunctional upbringing, had caused him to lose control. Suddenly, I was learning how his whole history with me had been about maintaining control. On one of the videos, Hegstrom pointed out that when abusers start destroying property, it's never their own. Generally, they choose to destroy things that are valuable to their partners. If it were a complete loss of

[5] See Appendix A. The Power and Control Wheel is a tool developed by the Duluth Model describing typical traits of abusive behavior. Much to my surprise, most of these tactics do not involve physical violence. To learn more, visit https://www.theduluthmodel.org/wheels/.

control, nothing would be exempt from their rampages. As I sat and listened, my heart began to grieve over all the lies I had believed. I had basically given my whole life to support and protect a man who had willfully chosen his selfish desire for control over the girls and me. I had foolishly believed he was the victim and he needed me. Even so, the information presented suggested I had also played a role in the disintegration of my marriage. I had accepted responsibility for his life and had even tried to shield him from the consequences of his sinful behavior. In addition, my interpretation of scripture had caused me to think I *had* to put up with his malicious control. So basically, while I had not caused the violence, I had certainly helped perpetuate the violent cycle.

The Life Skills training directly countered my faulty responses to Doug's violent outbursts and suggested that accountability was necessary to help families break the cycle of domestic violence. They said that fear of consequences would deter many (not all) abusers from further violence. That was the theory I had tested and proven after reading *Love Must Be Tough* over a decade ago. However, this time around, I hadn't been able to get the help I needed to hold him accountable. The church had backed out of the situation, and law enforcement rarely responded to my calls. Even when I filed for a protective order, there was really no indication there would be consequences if he violated it. It seemed like the whole system was in his favor.

If I thought my inability to hold Doug accountable

was discouraging, the final portions of the Life Skills training left me baffled and even more dismayed. In addition to the illuminating materials developed by DV programs, the Life Skills curriculum focused heavily on past trauma, citing it as the driving force behind abusive behavior. Hegstrom stated that all the abusers he had ever met had experienced trauma as children, which had arrested their emotional development. The key to healing for the abuser was to go back into his past to identify the traumas (particularly the first one) that had hindered his maturity. Somehow, in reliving the hurts of the past, healing would come. Even more enigmatic was the possibility that some of those traumas might only be carried in the subconscious and may not come to the surface for years. Doug had definitely experienced a tumultuous childhood and had no problem remembering it, but this suggestion opened up the possibility that it was worse than he remembered.[6] The thought of reliving it was not at all appealing to him, and this only added to my fear that we could not be restored.

As much as I wanted to apply what we had learned with Life Skills, it did not take long for the violence to

[6] While I agree that traumatic childhood experiences can and do influence behavior, I do not agree with Hegstrom's assertion that they *cause* it. I have met many abuse survivors who are not abusive. People still have the freedom to choose their behavior, and healing is more likely to come from confronting heart issues than from trying to dig up buried memories.

return. As soon as we returned home, Doug decided it was too expensive to maintain separate houses and, since he had complied with my desire to attend Life Skills, I needed to come back home immediately. I reminded him that making demands was not the way to win back my trust, but the situation quickly deteriorated. I called Life Skills and spoke to Judy Hegstrom. She told me that if Doug wasn't willing to change, I needed to be willing to move on with my life without him. It seemed as though all hope was gone and, as much as I hated the idea of divorce, I was starting to see that a marriage couldn't be saved if only one person was trying. I also realized that safety had to be my number one concern, but it was not so easily achieved.

On his birthday in July, Doug asked if he could see the kids after church. Haley had gone home with a friend, so I told him that. He responded that he didn't want to spend the day alone. I resisted his pleas, but he countered all my concerns about safety with promises of being on his best behavior as he cried about how lonely he was. Finally, I gave in and drove over to his house. I told him I would leave Hannah and come back later, but he begged and pleaded for me to come inside—after all, nobody should have to spend their birthday alone wallowing in self-pity. Once again, he managed to persuade me to go against my instincts. As soon as we got inside, it was clear that seeing Hannah was not his priority. He began to beg me to take him back and then begged me to have sex with him—even with Hannah

sitting right there! When I refused his request, he suddenly turned from cajoling and sad to fierce and demanding. He grabbed me and began to drag me upstairs, all the while muttering something about rape. He managed to get me upstairs and we struggled there for a while.

I was eventually able to break away and get back downstairs, but he was right behind me. I told Hannah to get up, but she didn't move—she appeared to be frozen in fear. Suddenly, Doug got behind me, put his arm around my neck, and began to apply pressure.

He said, "Let's just end it right here!"

I could feel the air being cut off as he jerked my body up and down. All I could think about was that he was going to kill me right in front of Hannah. I couldn't let that happen, so I tried to tell her to call 911 whenever I was able to speak each time he let my body down. My vision started to blur, and all I could do was pray for deliverance. Somehow, I thought to turn my head sideways and was able to slide my head down under his arm when he let me down again. I fell to the floor and he went to the couch to Hannah. He began crying, hugged her, and apologized over and over. Since he seemed broken, I was able to get her to come to the car with me. For days afterward, my voice was hoarse and my whole neck hurt. Yet, from the outside, I looked completely unscathed.

That strangulation attempt was the final straw for me. I realized having any contact with Doug was far too dangerous, and I knew I needed to move away. I was

from North Carolina, so I began to search for a job closer to family there. Haley, Hannah, and I moved away just a few months later. I gave Doug only a cell phone number and a P.O. address so he could send child support checks. The cell phone was a bad idea because airtime was expensive back then, and he called scores of times each day. Sometimes he hung up and other times he left threatening messages, but either way, he used up so much airtime that the first month's bill was as high as my rent.

Chapter 9
New Beginning

See, I am doing a new thing! Now it springs up; do you
not perceive it?
I am making a way in the wilderness, and streams in the
wasteland.
— Isaiah 43:19

In the midst of all the turmoil, God was ever gracious.
At my new job, there were several other Believers who
held me up in prayer over the difficult months that
followed. Twice I had to take off work and drive all the
way to Virginia for domestic court, only to find that
Doug had had his attorney continue our case. I
continued to struggle with the thought of divorce but
one day, as I was reading 1 Corinthians 7, verse 15
seemed to jump off the page at me. Paul said if
separation occurred because an unbelieving spouse left
the marriage, the believing spouse was not under

bondage because "God has called you to peace." Before, I had always focused on the instructions in these verses, rather than the heart of God in them. Suddenly, I was struck with an overwhelming realization that I had not had peace in over twenty-three years. I had lived in torment for over two decades and, in that moment, I knew this was not what God desired.

While I tried to establish a more peaceful life, turmoil seemed to follow us. Eventually, Doug found my house and burst in while my mom and brother were visiting. He threatened to kill us all, but my brother was able to get him out. That week, I went and filed for another protective order. Even after the order was granted, he continued to instill fear in me from a hundred miles away. I had all the signs of PTSD and often woke up with nightmares of him coming at me with a gun or a knife. I was always on guard and filled with anxiety, but that only caused me to press in and seek the Lord more fully. I knew only His grace and mercy would enable me to overcome the aftershocks which continued to plague me.

As I settled into my new home, I often found myself longing to be back with Doug. To be fair, I was grieving the loss of my marriage, but it was also like breaking an addiction. Over my years with Doug, I had conformed my thinking to please him. I had even conformed myself to his preferences and prejudices. After living to please him for decades, I didn't know how to live on my own. My emotions were erratic, but I was learning that I could not live by feelings. I chose to

believe God's truth, even when I didn't feel like it. After our separation, I had found that writing out passages of scripture and posting them in conspicuous locations helped me to counter negative thoughts and emotions. God was also faithful to place appropriate studies in my life at just the right times.

A few months before I had left Virginia, our ladies group did another Kay Arthur study. The title of this study was *Lord, Heal My Hurts*. When I first picked up the book, I saw references to forgiveness and asked the Lord, *How can I forgive him?* By the time I had moved to North Carolina, though, and had finished that powerful study of Jeremiah and Matthew, I knew I could not possibly withhold forgiveness. When I finally forgave Doug, it was as though I had been set free. I hadn't realized how horribly anger and unforgiveness had been affecting my life, but when I was able to forgive, the change in me was incredible. Forgiveness did not lead to reconciliation, and it did not restore my trust in Doug, but it did completely release me from the bondage.

Another powerful truth reinforced by Arthur's book was the fact that God's truth trumped man's wisdom. My father had introduced me to Freudian psychology at an early age and, even though I couldn't find much hope in it, I generally believed the basic tenets. One such tenet said that trauma, such as abuse, caused scars which would last a lifetime, with no hope for healing. I thought this meant the children and I were doomed to a future filled with pain and grief. However, *Lord, Heal My Hurts* let me know that scripture reveals truths that countered

this belief. Arthur compared the philosophies of men to Jeremiah's empty cisterns that couldn't hold water or satisfy (Jer. 2:13). Rather than succumbing to the lie that my children and I would always be victims, I decided to choose to believe God's truth.

In the years that followed, God persistently and gently continued to show me His freeing truth. If He had shown it all at one time, I never could have handled it, but He was faithful to give me just what I could bear. Part of the truth I had to face was my own sin. I had given God's glory to a man, and the result was an unholy, sinful fear which made Doug bigger than Him. Such fear thrives on lies. I believed lies, told lies, and basically lived a lie. By the time Doug and I separated, we had been together for over twenty-three years. For over half my life, I had chosen deception over truth. Overcoming that took time. Sometimes it seemed as though each new day brought a revelation of truth that I had suppressed, but through personal quiet time and group Bible studies, God's truth continued to challenge my faulty thinking.

Over time, I realized the worst distortion in my thinking related to my view of God. Basically, even though I knew He was loving, I viewed him as rigid and demanding—just as Doug had been with me. It was as if I had remade Him into Doug's image. Although I knew what grace meant, I surely didn't live by it or extend it to others. I was hard on myself and on others—especially when it came to divorce. I was judgmental and actually thought I was representing Him well when I

disapproved of all divorce, no matter the cause. However, losing everything has a strange way of helping you see your desperation for His grace, and once you receive it, you can't help but want to extend it to others. Even though I would have never chosen to suffer as I did, I came to realize that suffering had done something beautiful in my life. Before, I said I trusted God, but I lived in constant fear. After my trials brought me to the end of every human resource, I found Him to be entirely trustworthy and was able to joyfully surrender my life to His loving care. I often tell people I would never have chosen that path of suffering, but I am so grateful for it, because if I hadn't experienced it, I wouldn't know Him the way I do now. Nothing in this world is more precious than knowing Him! The more I came to know Him and His truth, the freer I became. Over time, it felt as though I had been released from prison!

Along with my newfound freedom, I had the assurance of God's presence and provision. Isaiah 54:6, in which the Lord promised to be a husband to His people, became especially precious to me. As I learned to trust Him fully, He proved to be truly wonderful and faithful. In time, I realized that rather than being a victim for the rest of my life, I had become victorious, and God wanted to use my experience for good. When I was in the midst of the abuse, I realized that without help, it is nearly impossible to get out, so I had promised the Lord that if I survived, I would help other women in similar situations. A few years after I came back to North

Carolina, He gave me the first opportunity to keep that promise, and as time went on, more and more opportunities arose.

Chapter 10
Reaching Back

Praise be to the God and Father of our Lord Jesus Christ,
the Father of compassion and the God of all comfort, who
comforts us in all our troubles, so that we can comfort those in
any trouble with the comfort we ourselves receive from God.
— 2 Corinthians 1:3–4

At one point, a lady and her three small children from the church I attended in North Carolina came to stay with me after she reported a strangulation incident at home. In the beginning, our church seemed supportive, but it didn't take long for her husband and his family to counter her story. I eventually got a call from the pastor saying the church really couldn't get involved because "in these cases, it's just too hard to tell who is telling the truth." I told him what the children had told me, which backed up their mother's claims, and

in response he told me to do what I thought was right, but since the truth was so unclear, he believed the church should stay out of it. He also let my friend's husband's family know that she was staying with me, so she no longer felt safe. In the end, I had to drive my friend to the nearest domestic violence shelter, Safe Space, for help. They helped her obtain a protective order, housing, and financial assistance. While I was there, I told them parts of my own story and indicated that I would love to become a volunteer.

A few weeks later, someone from the shelter called and asked if I would give a brief testimony at an upcoming vigil to remember victims of domestic homicide. Even though I had always been terrified of speaking in public, I realized that God had not brought me this far just to have me hide my light, and I reminded myself that I really could do all things through His strength. When the night of the vigil arrived, I was extremely nervous but asked the Lord to calm my heart. As I opened my mouth, He answered that prayer, and I was able to testify of His goodness and truth which had set me free. When I finished speaking, one of the board members stood up and hugged me. A week later, they called to offer me a job as their Community Educator. For over a year, I had to speak in public almost weekly. I provided training for law enforcement, educators, and civic groups, but the church was conspicuously absent. It grieved my heart that the Body of Christ was missing the opportunity to minister to so many hurting families.

Although Safe Space had hired me to be the Community Educator, I believe the Lord placed me there also to be educated myself. I learned that the statistics related to domestic violence are just as high in the church as they are in society in general, and I met scores of precious, Christian women who proved those numbers. In fact, it seemed their abusers regularly used their faith to keep them in line, just as Doug had always used my belief in scripture against me. He often reminded me of his headship over me and demanded that I submit. At the shelter, I heard the same story again and again, and everyone seemed baffled about the church's lack of response. Within a few months, I decided I would try to reach out to churches in the area and offer training. I wrote a letter and sent it to every church I could locate in our rural county. The letter included a survey about DV within their congregations, along with a self-addressed, stamped envelope to return it. Out of over two hundred surveys we mailed out, only ten came back, and over half of those had been completed by women in various ministry positions.

Safe Space arranged a call-in radio show appearance to promote our training for churches. The first call I answered was a lady asking me why her pastor kept sending her back to an abusive man. The second caller asked me why the church refused to believe her, and on it went. It was clear to me that we had touched a nerve. Later on, I did a call-in television show on one of the public access channels. The results were similar, and there were far too many callers to

respond to them all. The host said they had never received so many calls in one show. When the day for our training came, only five of the two hundred churches we contacted were represented. Safe Space had allowed me to openly proclaim my faith since it was part of my story, and we asked a few local pastors to lead prayers or speak on related biblical topics. Besides those participating pastors, only one head pastor showed up. The other church representatives ranged from ministers of education to youth ministers to women's ministry leaders, and three out of five were women. It was all rather disheartening.

After our attempt to train local pastors, I decided to reach out to counseling professors at nearby Southeastern Baptist Theological Seminary (SEBTS). As a fellow Southern Baptist, I thought they might be more responsive to me. One of the professors agreed to meet with me. I shared my story and asked if he would consider allowing me to share with his classes. He seemed genuinely interested in doing something to help. When I called the other professor, he didn't really seem interested in meeting but was willing to talk over the phone. I asked him his strategy in cases of domestic violence and was actually pleased to hear he had one. This professor told me that when he'd faced domestic violence in his church, he'd confronted it, made sure the church provided housing for either the husband or wife, and continued to work with both spouses until they could be brought back together. This was done slowly and gradually, beginning with dates in public, and

eventually bringing the abuser back into the home for limited periods of time. I actually thought it could work, even though the DV shelter statistics for long-term reconciliation were pretty dismal (only 2–3 percent).

Shortly after my conversation with him, I quit Safe Space to spend more time with my new husband and our four teenagers (that's another story). A few years later, God very clearly called me to Southeastern to study counseling. When I enrolled, I did not even realize the counseling program at SEBTS was a biblical counseling program. The basic premise was that proper application of God's Word and His Spirit are the most powerful means of achieving emotional well-being. Though I felt that some early proponents of the biblical counseling movement were harsh in their application of scripture, I agreed with the overall concept. After all, it was God's Word and truth that had healed me. As Believers, scripture should always be our standard, and we should reject psychological models that do not line up with His truth.

My training in biblical counseling was quickly put to use in my own church, and as folks at the seminary learned about my expertise in the area of domestic violence, I received many referrals to work with cases of abuse. Based on these experiences over the years, I noticed some common themes in church counseling that tended to worsen matters. I have seen pastors and counselors at a loss for how to handle the complexities that nearly always come up. Often, churches become ineffective to help as they get caught up in trying to

figure out who is telling the truth, and generally, abusers tend to win that competition. Without some understanding of the dynamics of domestic violence, it is easy to mishandle this issue. In many evangelical churches, women are encouraged to submit to their abusers as long as they are not requiring them to sin. The inadvertent consequence of this counsel is the enabling of the abusers' sinful heart motives, while further discouraging the victims.[7] Many have told me they felt doubly abused: first by their husband and then by the church. Some women I have worked with have even faced church discipline for failure to submit.

On the flip side, I have seen very little accountability required from the abusers, and churches unwittingly end up perpetuating the cycle of abuse. I have seen it time and again, and every time my desire to help has intensified. The final result was founding a nonprofit parachurch ministry to help families affected by domestic violence. Called to Peace Ministries was established in 2015 to provide practical assistance, biblical counseling, and support groups for victims/survivors, as well as education for those who desire to help.

[7] Many Christian women believe they have to submit to just about anything their abusive husbands demand, but that only serves to promote sin. I wrote a blogpost about marital submission and abuse at https://joyforrest.wordpress.com/2014/02/26/biblical-headship-and-submission-in-emotionally-abusive-marriages/. This article was based on a paper I did in seminary and approaches the subject from a traditional, complementarian perspective. I believe that even those who hold this perspective should understand that scripture does not command wives to submit to husbands who intend to harm them.

After spending over a decade counseling within the church, I have seen how detrimental couples counseling is in these cases, and how limited resources are for victims. The DV shelters do a great job of helping victims get safe, but most shelters only allow them to stay for 2–3 months. For the majority of victims I've met, that just isn't enough time to get a life together. In addition to helping survivors find healing, Called to Peace Ministries strives to fill many of the gaps in services by meeting the multiple needs of victims and their children. We also provide education to counselors and pastors on how to develop effective intervention strategies.

People are destroyed by a lack of knowledge (Hos. 4:6), especially when it comes to domestic violence. We desire to provide knowledge that will help free families from its devastating effects. If you are living with domestic violence, I want you to know that God is more than able to turn your ashes into beauty (Is. 61:3). He holds the keys to healing. I know it firsthand because He has healed me, as well as many others I know. Over the years, I have had numerous chances to listen to the stories of women who have struggled with this disturbing issue. I have been shocked by the brutality of the abuses but amazed by God's ability to use pain and suffering to mold His children into His likeness. What a wonderful Redeemer we serve! He is able to heal completely and redeem every sorrow. He loves you dearly and calls you from violence to peace.

Part Two

Keys to Finding Peace & Healing

Heal me, LORD, and I will be healed;
save me and I will be saved,
for you are the one I praise.
— Jeremiah 17:14

Chapter 11
Education & Truth

"My people are destroyed from a lack of knowledge..."
– Hosea 4:6

One fine day in the spring of 1996, I lied to a judge. This happened shortly after taking an oath to tell the truth, the whole truth, and nothing but the truth. Oddly enough, I didn't feel even a twinge of guilt because, at the time, I didn't believe I was lying. I testified to the judge that my marriage of fourteen years had not been abusive at all. Rather, some recent stress had caused my husband to snap and act completely out of character. It was a story I wholeheartedly embraced because I had been telling it to myself for so many years. I was there to have him convicted of assault, but I told myself the assault was the result of some sort of nervous breakdown rather than the result of a pattern of abuse. Up until that point, there had been numerous incidences

of violence, but it didn't happen on a regular basis. In fact, several years were completely violence-free. Perhaps another reason I did not think I was abused was the image I had conjured up in my mind about abuse victims. When I thought about domestic violence, the term that came to my mind was "battered," and I was certainly not battered. In the entire length of our relationship, he had never once punched me with his fists. Our rare physical altercations usually began with something like a shove or being jerked by the arm. Once I had my fingers slammed into a drawer and once I was kicked. Oh yes, and there was that time when he held a knife to my throat but, no, I wasn't battered.

Perhaps believing lies was my way of trying to convince myself that things really weren't that bad. So when I finally did have to admit I had been in an abusive relationship, I felt like a complete fool. I had always considered myself pretty bright, but facing the truth challenged that belief. Another thing the truth challenged was my idealistic concept of my husband's opinion of me. I thought my ability to elicit such great emotion from him meant he truly loved me. It didn't matter that his actions toward me were the exact opposite of the biblical description of love:

> Love is patient, love is kind. It does not envy, it does not boast, it is not proud. It is not rude, it is not self-seeking, it is not easily angered, it keeps no record of wrongs. Love does not delight in evil but rejoices with the truth. It always protects, always trusts, always hopes,

always perseveres.– 1 Corinthians 13:4–7

Whenever I came across this passage in my quiet times, I couldn't help but notice that my husband's actions toward me were most often the reverse. It didn't take much for him to lose his patience with me, and within my first month of knowing him, jealously reared its ugly head several times. I can't tell you how many times he embarrassed me in public by making rude comments toward others, the kids, or me. I felt so vulnerable when I was with him—certainly not protected. It was his way or no way, and lies were the foundation of our relationship. However, the most blatant contrast between godly love and my relationship was found in verse 5, which states that "love is not easily angered." There were times when I couldn't believe how seemingly insignificant details could enrage my husband, and over the years, I've heard countless stories from other victims of abuse who suddenly found themselves the object of wrath when a small detail set off a reaction of atomic proportions.

One dear lady told me she received a horrible beating simply because she left hamburger meat in the sink to thaw, while another was belittled to the point of tears in front of her children because she failed to fold and stack her towels in the "correct" manner. My ex tore apart the entire house (throwing things against the walls and clearing counters of their contents as he went through each room) after one of our children moved his hairbrush from its prescribed resting place in the master bath. In recent years, a friend told me that just leaving

one cup in the kitchen sink would send her husband into a rage. I would call that being "easily angered," and it took me years to realize that true love does not act that way.

It takes a lot for most of us to realize and admit the truth. We tend to lie to ourselves because the truth is almost more painful than the abuse. It means acknowledging that our partners' actions do not equate to love at all, so most of us make excuses for them and convince ourselves that they have little control over their angry actions. I truly thought my husband was not in control when he blew up and I needed to try to hold things together so he wouldn't have a reason to lose it. I thought he needed me, and so I built my life around making things go as smoothly as possible for him. I realize this is probably contrary to the average stereotype about domestic violence. Some people who are unfamiliar with DV believe domestic abuse is the result of heated arguments, which could have been started by either party. Certainly no man would physically harm his wife unless she had done something to provoke him, right? It seems like a logical conclusion, but the problem is that in the vast majority of cases, it's a faulty one.

Most abusive people are self-seeking, easily angered, and impatient, along with all the other contradictions to God's love listed in 1 Corinthians 13. In his book, *Why Does He Do That? Inside the Minds of Angry and Controlling Men,* Lundy Bancroft states, "An abuser almost never does anything that he himself considers

morally unacceptable. He may hide what he does because he thinks other people would disagree with it, but he feels justified inside." [8] After working with victims and abusers for nearly two decades, I'd have to say this assessment is spot-on. Unfortunately, it is not something most of us would like to admit. It is so much easier for us to believe our partners are abusing us because they are wounded inside, or because they lack coping skills due to emotional problems or substance abuse, than to admit they are actively choosing to hurt us. Coming to terms with the truth was almost too much for me bear, so I lied to myself until the day somebody placed a tool called the Power and Control Wheel into my hands.[9]

The Power and Control Wheel was created by the Domestic Abuse Intervention Project of Duluth, Minnesota in 1984 and is based on observations of focus groups of women who had been physically abused. When project personnel began to interview these women, they discovered patterns of control and manipulation that seemed to exist almost universally within the groups. As they began to document these common behaviors or tactics, the result was a tool that has been used by victims' advocates for over three decades. The first time I laid eyes on a Power and Control Wheel, I cried, as have numerous victims with whom I have shared it over the years. It's pretty easy to

[8] Bancroft, Lundy, *Why Does He do That?* (New York, Berkley, 2002), 31.
[9] See Appendix A

deny a relationship is abusive until someone puts a detailed description of your life right in front of your eyes! For years I suffered in silence, thinking nobody knew what I was going through, but when I picked up the Wheel, it seemed as though somebody had been a silent observer of my life for over two decades. I was also amazed to find I was not alone and that at least one in four women experience physical abuse from an intimate partner within their lifetime.

One thing that stands out to most observers is that the majority of behaviors listed on the Power and Control Wheel do not involve physical harm. I had denied that my relationship qualified as domestic violence simply because physical altercations were somewhat infrequent. However, the tactics described on this diagram happened on a daily basis. According to this tool, bodily harm is simply the last resort when all other tactics fail to achieve the desired power and control. Domestic violence is not merely about physical harm, but about abusers establishing patterns of complete domination over their victims. Basically, the motivation is far more telling than the behavior. In his book, *The Heart of Domestic Abuse,* pastor and biblical counselor Chris Moles states that abusive behavior "is driven by a heart of pride and self-worship."[10] True domestic violence is not merely a reactive pattern of behavior, but one that is intentionally self-serving. In

[10] Moles, Chris, *The Heart of Domestic Abuse: Gospel Solutions for Men Who Use Control and Violence in the Home* (Bemidji, MN, Focus Publishing, 2015), 43.

fact, a look at the behaviors listed on the Power and Control Wheel shows just how self-seeking abusive conduct really is.

Coercion and Threats

At the top of the Power and Control Wheel, we see that abusers use coercion and threats to maintain control. In the years I have worked with victims, nearly all of them have confirmed that these behaviors were used regularly in their homes. Some abusers threatened to leave their families and not provide for their basic needs, some threatened suicide in order to make sure they got their way, some threatened physical harm, and others just threatened to humiliate their wives somehow. In several cases, I've seen abusers go out of their way to make their wives look incompetent. After years of living with control and manipulation, my friend Jill became seriously depressed and ended up being prescribed anti-depressants. Her husband made sure he let the pastor know how concerned he was about his wife's erratic behavior, her inability to parent properly, and her dependence on medication. Of course, the church had no idea of what really went on behind closed doors, and Jill knew better than to try to tell them. At the same time, Jill's husband made sure she knew if she decided to leave the marriage, he would have no trouble having her declared incompetent and getting full custody of the children. For Jill, this threat was far more powerful than bodily injury ever could have been. Her husband's threats were highly effective in promoting his selfish

interests.

Using the Children

Abusive people tend to aim their threats directly at whatever their victim values most, so that means threats involving children are very common in these situations. In fact, many women stay in horrible situations for far too long because they know if they leave, their spouses may harm the children. Such was the case with my friend Amy. She had endured occasional physical violence and relentless threats from the beginning of her marriage. Her husband kept a gun beside their bed and let her know that if she ever tried to leave him, he would use it on her. He even held it to her head on a few occasions. She knew she needed to leave but was concerned about her children if she did because he told her that even if she left, he would "still have the children." She was never sure what he meant by that, but she knew it wasn't good. Finally, there came a day when she felt if she didn't get out, she would not live to parent her children at all, so she mustered up the courage to take them with her and leave. Shortly after their separation, Amy had to go to court to try and get legal custody of the kids. She told the judge her concerns about the children being with their father, but he granted regular, unsupervised visitation to her husband anyway. Amy wanted to believe her husband wouldn't make good on those vague threats, and she also wanted to believe the court had made the right decision. However, within a short amount of time, her three-year-

old son came home and reported that he had been locked in a closet and his sister was being sexually abused. Amy was finally able to stop the unsupervised visitation, but she knew then that the threats against her children were not idle.

Unfortunately, Amy's story is not an exception when it comes to domestic violence. In my own exposure, I have seen abusers intentionally hurt their children multiple times in order to punish their spouses. In other cases, it is not unusual for them to attempt to turn the children against their mothers. Basically, abusers will do whatever they consider necessary to maintain control, regardless of the consequences to the children. I have seen women frozen in fear because of these types of threats, but those I have known who've decided to leave all tell me they made the right decision—even Amy. She believes things would have been far worse had she stayed. Living in fear of a man will never lead to the life God intends for you. Ask Him to help you devise a plan to leave, and be sure to utilize all the resources available to you. Your local domestic violence shelter can help you create a safety plan and can connect you to legal resources to help you with custody issues.

Intimidation

Besides using the children to hurt their wives and partners, abusers make regular use of intimidation techniques to instill fear and attain unfettered power in their families. Intimidation can range from a harsh look

to extreme, physical violence. Most abusive people have conditioned their victims to know when they are about to snap. As a result, a single angry glance can cause victims and their children to completely freeze up or change their course of action. If a nasty look doesn't get the desired result, or if the abuser is feeling particularly grumpy, he may resort to more physical tactics such as throwing and smashing things, destroying property, or even abusing the household pets. When I was working at the shelter, one of the clients told me her husband decapitated her dog in front of her and their children. Countless other victims have told me that their family pets often received the brunt of the abuser's wrath. Another lady told me her husband once filled her car with poisonous snakes just to make sure she didn't go anywhere.

Intimidation is a highly effective tool for perpetrators of domestic violence, and it usually escalates in intensity. Some of the behaviors often seen in the progression of violence include blocking the exit from a room, screaming, raising a fist, denying access to prescription medicine, grabbing, jerking, shoving, spitting, pulling hair, and so on. If these methods do not work, then punching, kicking, and other methods of inflicting more serious physical harm are likely to follow. An interesting thing to note here is that even when hitting occurs, many abusers, in an effort to keep the abuse hidden, maintain enough control over themselves to make sure they hurt their victims in a way that doesn't leave obvious bruises.

Emotional Abuse

Women who live with domestic violence often tell me they prefer hitting to the emotional torment their abusers put them through. The Power and Control Wheel calls it emotional abuse, and while some may not agree with the terminology, there is definitely an emotionally destructive element to these relationships. "Emotional abuse systematically degrades, diminishes, and can eventually destroy the personhood of the abused."[11] Tactics include putting her down, humiliation, making her feel bad about herself, name-calling, mind games, making her think she's crazy, and making her feel guilty. Several years ago, I watched a friend in a store ask her husband if she could purchase a three-dollar item. Rather than saying yes or no, her husband began to put her down in front of everyone present. He asked her how she could be so foolish as to want to buy something that cheap and said she probably wouldn't even use it. As he was criticizing her for her stupidity, he looked over at us and chuckled. It was clear he enjoyed taunting her and that he saw her as inferior. Her face turned red as she tried to mumble answers to his questions until she finally put the item back to avoid further humiliation. It seems silly that something so small could ignite such fury, but that's the nature of emotional abuse. Molehills become mountains on a

[11] Vernick, Leslie, The Emotionally Destructive Marriage (Colorado Springs, Waterbrook Press, 2013), Kindle Version Location 256.

regular basis when you live with an abuser.

One woman at the shelter told me she would sometimes purposely do something to get her husband to hit her, just because she knew that once the abuse was over, there would be a break in the verbal assaults for a while. Victims are made to feel like they are constantly wrong, incompetent, and worthless. No matter what the issue, and no matter who is right or wrong, everything gets turned around and the victim ends up getting blamed for everything. The sad thing is abusers are often skilled enough to convince counselors and pastors that their wives really are to blame for most of the problems in the marriage. Abusers go to great lengths to portray themselves as morally superior and intellectually more reasonable than their victims. By the time they get to counseling, many victims are so overwhelmed and insecure about themselves that they do, in fact, seem unstable.

Isolation

Abusers love to isolate their victims from people and situations that might provide them with support. I have had women tell me that after getting married, they eventually lost every single friend. My friend Kathy was rarely allowed to see her family, even on holidays. On several occasions, her husband reached out to her friends and family and told them it was her decision to cut off the relationships. He led them to believe she was mentally unstable, and he was doing his best to make things easier on her. However, he was the one

controlling her contact with others. She was basically allowed to go to church (with him) and to the grocery store—as long as she wasn't gone too long and came home with a receipt to prove her whereabouts.

Controlling people use isolation to make sure their victims have nowhere to turn when things get tough. Most of them live in fear of losing control, so they go to great lengths to maintain it. Linda's husband, Dave, bought a seventeen-acre farm twenty minutes from the nearest town, and he had the only car in the family. He was retired, so Linda had him as her constant companion. Although he didn't *physically* harm her, Dave controlled what she ate, what she read, and even her opinions. She was not allowed to disagree with him in any way. When I met her, they had been married for over thirty years and, up until just before she came to the shelter, he had never laid a hand on her. Despite not allowing Linda to have friends, Dave had several, and when he invited his friend Carl out to visit, Carl would bring his wife, Lucy. This was the first friend Linda had been allowed in years and she was grateful. One day when the men were out hunting, Lucy told Linda that she needed to stand up to Dave's bullying and let him know that she had a right to her own opinion. A few days later, she did just that, but Dave went ballistic. He beat her with a skillet so badly she nearly died, and he ended up in prison. For all the years they had been married, isolation had achieved its goal. When she was completely isolated, Linda was too afraid to refuse any of Dave's demands, but as soon as she found some

external support, she found the courage to challenge him. Unfortunately, the price of freedom was steep for Linda, but in the end, she was able to escape his control.

Minimizing, Denying, and Blaming

Grace had been married to Charlie for over ten years and was a stay-at-home mom. Although she went to extreme measures to please Charlie, he criticized her constantly. The house was never clean enough, the kids were never good enough, and meals never seemed to meet his approval. One day Grace decided to cook two meals in an attempt to find something he would like. He came home late, went straight upstairs, and ignored both meals. Soon after, Grace discovered Charlie was seeing another woman and he'd had dinner with her that evening. When she confronted him, Charlie turned the whole situation back on Grace. First of all, he explained, he had done nothing wrong, and she was being ridiculous. He criticized her for even bringing it up, and when she pressed him on the subject, he started blaming her for his actions. Maybe if she had been more attentive to his needs or managed to do something right from time to time, he wouldn't have needed to find outside companionship. Basically, he told her she had no right to question his actions, and if she wanted to see things improve in the marriage, she needed to try harder.

One day Grace caught Charlie slapping their nine-year-old son, but he simply acted like it was no big deal. When she expressed her concern that it was contributing

to their son's anger issues, he turned it back on Grace.

"Of course, he's angry! He has to live with you!"

No matter what she said or did to confront the wrongs against her children and herself, Charlie either denied wrongdoing, minimized it, or blamed someone else. He never accepted responsibility for his actions.

Economic Abuse

Jan's husband Buddy put her on a very strict allowance, and it usually fell far short of meeting the basic needs for their family of six. When she went to the grocery store, Jan had to bring back her receipt so Buddy could analyze every item she bought. He ridiculed half of her purchases and called them wasteful. On the other hand, she had to make sure she bought him special (and somewhat expensive) snacks that nobody else was allowed to touch. When extra expenses popped up, such as prescription co-pays or extracurricular fees for the kids, Jan didn't have enough money to cover them. She had two little ones in diapers and one on formula, but the budget barely allowed for these items. If she ran out of money, Buddy ridiculed her for being frivolous. Eventually, Jan decided it might help to take on a part-time job in the evenings to help out, but he refused to let her work. Although he constantly claimed to be broke, he often bought high-dollar items for the kids and himself. The older kids were given the latest smart phones, and he bought a boat, but Jan was still using an old flip phone her sister had given her several years back.

Buddy made sure Jan did not have access to his income or bank information. She only had access to the joint account he'd set up for her allowance. At tax time, he simply had her sign their tax returns without looking at them, but one day she caught a glimpse at his annual income and found that, in spite of his claims of being broke, he was earning well over six figures. She was barely surviving on what he gave her, but he wasn't struggling at all. He simply enjoyed wielding power over her.

Using Male Privilege

When Jan finally got up enough courage to ask the church for help, Buddy discredited everything she said. Since she had struggled with postpartum depression, he used that to convince the church she was completely unstable. Buddy was considered a leader in the church, and his outstanding service gave people little reason to doubt him. On the other hand, Jan usually seemed pretty frazzled. She had been in a Bible study I had taught a few years prior. At the time, Buddy approached me to say he hoped I could help her with her issues. He acted like she was very troubled but didn't give me details. He seemed like such a good guy that even I fell for his portrayal of her.

When she approached me in tears two years later, we set up a meeting and I'm ashamed to say that at the time, I doubted her more than him. Eventually, as we met, I began to recognize the abusive patterns, and I approached our pastor to say I felt the situation was

potentially dangerous. He responded that I was only hearing one side of the story and he believed Jan was "making up lies to destroy her husband." When I asked why she would do such a thing, he referred me to years of joint counseling sessions in which Buddy was able to get her to admit she was wrong for accusing him. Buddy had also shown him a video of Jan "freaking out" and yelling. Of course, there was nothing on the videos showing what led up to that, but his efforts to discredit her were hugely successful. The consensus among church leaders was that he was a great guy with a very troubled wife. The worst part of it was that he was able to use his role as head of the house to keep Jan subdued. At home, he reminded her that she was to submit to him and did not involve her in any family decisions. He basically dictated how things would be. In counseling sessions, he often complained that Jan was not submissive. In addition to exercising male privilege, Buddy used spiritual abuse as he twisted the concept of marital submission in order to force his selfish agenda. As with all the tactics abusers use, the ultimate goal is self-seeking.

Chapter 12
Managing Your Emotions

Trust Him at all times, O people; Pour out your heart
before Him; God is a refuge for us.
– Psalm 62:8 (NASB)

Coming through abuse usually leaves us overwhelmed with emotion and, over time, many of us might even shut down or become numb to escape the pain. In fact, the ladies in our support group say they know they are starting to heal when they begin to feel again. There was a time when all I could do in my spare time was lie around and watch old movies. Anything else required too much energy because I was so emotionally drained. Sometimes it is just easier to check out mentally than to feel. I have met many women who used drugs or alcohol to escape the pain of their negative emotions, but in the end, it made matters

worse. However, we serve a God who heals the brokenhearted and binds up their wounds (Ps. 147:3).

Finding healing means facing the truth about what is happening to us, putting it in His hands, and applying His solutions. In this chapter, we'll take a look at how that works with the major emotions we experience with abuse—anger, sadness, and fear.[12] You'll likely notice that there is much overlap between these emotions and the solutions for healing.

Anger

In my years of counseling victims of domestic violence, I have met some pretty angry people, and in many cases, their stories have angered *me* as well. Domestic violence can be unimaginably cruel, and it is difficult to hear the accounts without feeling upset about the injustice of it all. Quite often, victims are not only injured by their spouses, but they also find very little support when they reach out for help. The judicial system frequently favors perpetrators, who tend to have greater financial resources and often seem more composed in court. Even churches can make matters worse for victims when they don't understand the dynamics of abuse, or they harshly interpret scriptures on marital roles. For victims, insult is added to injury on

[12] I considered adding shame to this list of emotions because it is definitely an issue for those of us who have experienced abuse, but for the sake of brevity, and since the healing keys offered here are effective for shame also, I chose not to deal with it separately here. Chapter 14 of this book addresses the ultimate solution for shame. To read more on this issue, see *The Soul of Shame* by Curt Thompson, MD.

a regular basis.

Living with abuse gives us plenty of reason to be angry, but sometimes our anger becomes sinful and destructive. Unfortunately, when that happens, we often find ourselves living with negative consequences. Proverbs 22:24–25 warns, "Do not make friends with a hot-tempered person, do not associate with one easily angered, or you may learn their ways and get yourself ensnared." We can easily find ourselves compounding the pain and misery of an already bad situation by allowing anger to rule our hearts. It is easy to find yourself responding with anger when you've lived with it day in and day out, but letting yourself be consumed by it will merely worsen the situation.

Becoming upset over violence and injustice is not only understandable, but it is also normal. Ephesians 4:26–27 seems to imply that anger is common, but warns, "In your anger do not sin; do not let the sun go down while you are still angry, and do not give the devil a foothold." The problem isn't becoming angry as much as it is failing to deal with it quickly. When we stay angry and allow it to control us, we are headed for trouble. It seems that unresolved anger opens our lives to Satan's destructive schemes (Eph. 4:26–27).

There was a time when I became so angry that I began to suffer physical symptoms. Even worse, I found myself snapping at my children for the littlest things. Rather than being able to offer them the love and support they needed to get through the devastating events they were experiencing, I found myself so

consumed with anger that I had nothing left to give. The problem with maintaining anger is that you can't simply contain it to one area of your life. It spills out onto others and "defiles many" (Heb. 12:15). It is like a poison that damages every relationship in your life, including the most important one of all—your relationship with God. During this period, I found myself feeling as if my prayers were hitting the ceiling. Although I continued to reach out to God, resentment controlled me rather than his Spirit, which left me isolated from my Helper. I needed to learn how to handle my anger biblically.

Divine vs. Human Anger

Scripture clearly tells us there are things that anger God, and we are created in His image as emotional beings. God's wrath is provoked by sin and *He hates violence*. In Genesis, God told Noah, "I am going to put an end to all people, for the earth is filled with violence because of them" (6:13). It was enough to cause God to want to destroy His own creation, so it is certainly understandable when we get upset about it. Even the second part of Malachi 2:16, which says "God hates divorce," indicates that He also hates it when a husband deals violently and unfaithfully with his spouse. The Bible is filled with passages proclaiming our Creator's hatred of injustice and unfaithfulness. As His children, we should naturally hate the evil He hates. Our problem is that we usually carry it a little too far. Rather than turning the situation over to God and leaving justice in His hands, we try to control it.

In reality, human anger reveals a lack of trust in God. We may be questioning why He has allowed bad things to happen in our lives and if He really cares. In our minds, we profess that He is good, but in our hearts we doubt it. We know His Word commands us to forgive, but we believe forgiving is like giving a stamp of approval to the abuse. Thoughts like this unconsciously charge God with injustice. When we see our offenders "getting away" with sin, we want to take matters into our own hands because it seems as though God is sitting back doing nothing. I know that's how I felt, and I became so miserable that I thought life was not worth living. Over time, God graciously intervened, but it was not an overnight event. It was a process which required me to take some specific steps.

Face the Truth

People who live with abuse live with lies, and I was certainly no exception. I told myself that my husband couldn't help it when he blew up and that he was simply a product of the environment he had grown up in. I tried to hide our violent episodes from everyone to the point that I almost seemed to hide them from myself. For over two decades, I went to great lengths to avoid the truth, until one day, I could avoid it no longer and found myself angrier than I had ever been. I was worn down by months of constant offenses. Doug had been calling and threatening me fifteen to twenty times a day. I was afraid not to answer because I feared if he didn't get me on the phone, he would come to wherever I was and

make good on the threats. Normally, I would just hold the phone away from my ear and let him rant because I learned that saying anything just made matters worse. During one particular call, I heard the screaming stop and put my ear up to the phone just in time to hear him quietly threaten suicide. He slammed down the phone and that was that. He had made similar threats in the past but had never followed through, and he usually started harassing me again within hours. However, this time I heard nothing for two whole days and soon became concerned about him. I drove past his house both days and noticed that his car had not moved. On the third day, I decided to take *my* key to *our* former home and go check on him. I was scared to death to go in but was so worried about him that I did it anyway. He was not downstairs, so I tiptoed upstairs and saw him lying deathly still on his bed. He looked extra pale, so I went up and nudged him. As soon as I did, he woke up cursing at me, and I ran out as quickly as I could.

Within a few hours I got a call from the county sheriff's department saying Doug had come in and charged me with criminal trespassing. They had a warrant for my arrest, and the sheriff urged me to turn myself in. I was released on my own recognizance, but I was furious! How dare he have me charged as a criminal when I was merely concerned for his well-being. Foolishly, I decided to call and let him know just how awful his action had been; the conversation only left me more upset. I told him he was the one who needed to be arrested for violence against me, but he said he had only

hit me one time in the entire history of our relationship. He basically *denied* being abusive, and I couldn't believe his nerve! My response was pure rage. By this point, I was learning to turn my strong emotions over to God, so I started writing in my journal, telling Him about all the horrendous things Doug had done over the years.

As I was banging out complaints on my computer keyboard, my friend Karen happened to call to check on me. I told her about my earlier conversation with Doug and the already lengthy list of offenses I was compiling.

Much to my surprise, Karen said, "Don't forget the time he tore up the house because he was mad at the cat."

I was confused because I didn't remember that incident at all. I only began to remember once she reminded me how she and her husband had provided housing for me after it had happened. The odd thing was that it had occurred only twelve months earlier! I was amazed I could forget it so soon, but I believe I had gone to such great lengths to hide it that I had almost convinced myself it didn't happen. For the most part, those of us who have been abused remember the abuse. I surely remembered the most traumatic incidents, but sometimes we lie about it so much that we begin to believe our own lies. I've met women who have casually told me they had no problem forgiving their abusive spouses, but they could barely talk about what had happened. Some who did open up were still making excuses or denying the severity of the abuse. That is burying anger, not dealing with it.

Entrust it to Him

After admitting the truth, we must put it in His hands. A great deal of healing happened in me the day I finally faced the truth and conceded just how horrible things had been. Let me clarify—I do not think I was healed simply because I finally told myself the truth. That was only part of it. The reason I found healing was because I poured out my hurts to God and committed them to Him. The truth was too overwhelming for me to handle on my own, but I knew my heart was safe with Him. Psalm 62:8 encourages us to pour out our hearts to God, and that is what I did on that day. When you face constant offenses, it will often require you to surrender your anger again and again, but it will guard your soul. Commit the offenses you have suffered to Him. It is the only way to avoid carrying them yourself, and He is far better equipped to handle them. Each night when you lay your head on your pillow, drop those heavy burdens at His feet and trust Him to fight your battles.

Choose to Forgive

For many of us, forgiving our abusers can be the toughest battle we face in the recovery process, but it is a necessary step in overcoming the anger that comes from abuse. Although it may seem that facing the truth about the hurts I had experienced would've made it harder to forgive, it actually helped because I realized it was too big for me to handle alone. I knew I could not face the pain without God's help. I also knew His Word

commanded me to forgive, but I needed a lot of help in working through it. At the height of my anger, our ladies' Bible study decided to work through Kay Arthur's *Lord, Heal My Hurts.* When I picked up the book, I noticed a chapter in the table of contents entitled "How Can I Forgive?" It was the very question I had been asking myself, and this wonderful Bible study helped me figure it out. When I was able to forgive, it was as if a thousand-pound burden had been taken off my shoulders.

There were a few common misconceptions I had to overcome in order to truly forgive, and I've seen many other survivors struggle with them as well. As a child, I was taught to forgive and forget. When my siblings and I asked for forgiveness, we were taught to respond with, "That's ok. I forgive you." Then we were expected to hug and make up. Basically, that formed my view of how the process should look, but it was a flawed perspective because it caused me to believe that forgiveness would always lead to reconciliation. I also thought forgiving meant I simply had to minimize or dismiss the offenses as though they had never happened. Thankfully, I was wrong on both counts. Biblical forgiveness is placing the offender in God's hands and leaving justice to Him. It is letting go of our own need for vengeance, but it is *not* dismissing the hurt as though it wasn't that bad or as if it had never happened. Romans 12:17–21 gives us instructions on dealing with those who harm us. It instructs us not to repay evil with evil and not to take revenge but to leave

room for God's wrath.

We must trust that He will handle the situation in His time and with perfect justice. Also, we need to refuse to stoop to our abusers' level by taking revenge. Usually when we refuse to let go of our anger and desire for retaliation, it is because we don't trust that His way of dealing with it is better than ours. We will never find peace until we realize He always has our best interest at heart and He is working all things together for our good (Rom. 8:28–29). Regardless of how things may look in the present, there will come a day when your abuser will have to bow before Him, perhaps in great fear and trembling, and confess that He is Lord (Ph. 2:10–11). We need to trust Him to make all things right in due time.

Resolve to Believe Him

Letting go of anger and believing God is definitely a choice and not a simple process. For me, it was hard work. It meant learning how to choose His truth over my feelings and trusting that He cared deeply for me— even when it didn't feel that way. One day a phrase from Isaiah 50:7 spoke to me. This prophecy about Jesus predicted He would set His face "like flint" to accomplish the Father's plan. There was something about His determination in this verse that resonated with me because I knew my outcome would be tied to my decision to believe Him. I decided I would resolve to believe, no matter what happened or how I felt. I pray that as you read this, you will decide to do the same. To overcome anger and its damaging consequences in your

life, you must determine to do it God's way rather than your own.

The Process

Dealing with anger His way requires taking several steps. It means being honest with yourself and no longer minimizing or making excuses for the abuse. In order to truly heal, you must face and give the full weight of the burden to God. Commit your anger to God quickly, and do not let it fester. Let Him fight your battles. Sure, there may be actions you will need to take to protect yourself and your children, but you won't have to try and control things or force your version of justice anymore. Choose to forgive your abuser, recognizing that it will set you free, and leave justice in God's hands. Correct any thinking that is contrary to God's truth and believe that God will redeem your sorrows. Remember that He is for you and even though He will not violate the free will of your abuser, He is sovereign, and He wants to use your trials for good. Finally, seek scriptures that provide instructions on wisely dealing with anger and choose to apply them. Please see Appendix B at the end of this book for a list of verses.

Sadness

There is nothing sadder than feeling despised and rejected by the one person you have chosen to love and honor above all others. Many times over the years, I struggled with suicidal thoughts because Doug's opinion of me was so low. Like many young women, I

dreamed of living happily ever after with a man who adored me. Instead, I felt worthless and hopeless. Nothing I said or did could stop the criticism and contempt he directed toward me on a regular basis, and it was devastating. I had made him and our marriage the center of my universe, so having to walk away from both left me shattered. Sorrow overwhelmed me until I was able to learn to surrender it to Him. Grief is normal in these situations, but we have a choice about how we will grieve. We can either become self-focused and filled with self-pity, or we can focus on God.

Grieve Well

There is nothing wrong with grieving. Jesus wept at the tomb of His friend Lazarus, and God is not so cruel that He expects us to just deal with it and move on. He longs to relieve your burdens, dear friend, and to carry your griefs and sorrows (Is. 53:4). Knowing that you do not have to carry the burden alone and that you can bring your heavy burdens to Him is so important. The picture of God as a comforter in Zephaniah 3:17 was particularly precious to me. "He will quiet you with His love, He will rejoice over you with singing." I often curled up into a ball and imagined myself lying on His lap as I poured my hurts out to Him. I knew in my spirit that He was rejoicing because I was bringing my burden to Him. I still treasure those times of grieving in His arms because He was so faithful, and I came to know Him on a deeper level than I ever had before. The process of healing from sadness and grief is much the

same as it is for anger. We must learn to trust His goodness.

Believe His Word

Praise God for His Word because as I sought Him in those pages, I found that the Perfect One loves and cherishes me unconditionally. I realized I had allowed a flawed man to determine my worth so I was filled with shame, but his opinion of me was based on lies. (We'll talk more about this in Chapter 14). Discovering God's heart toward me was extremely healing. As it turned out for me, unresolved anger turned inward and manifested as depression, but I've seen it the other way around too. Some people mask their sadness by lashing out in anger. The two are quite interrelated, so the cure is the same either way. Pour your heart out and roll the burden on to Him. Choose to be controlled by the truth revealed in scripture rather than by your feelings. This doesn't mean the sadness will automatically disappear, but as you move closer to Him, you will find healing. Grief comes in waves. Just when you think you're recovering, another wave (a memory or another trigger) comes and knocks you over. But just as we can get past the breakers by moving forward in the ocean, we can move past grief by seeking out and moving toward our loving Redeemer.

Fear

Camille worked very hard to keep her husband Jack happy. She tried to make sure dinner was on the

table and the house was clean before he got home every day. However, every now and then, her day wouldn't go as planned. Once in a while, one of the kids would make a mess just before Jack walked in the door, or she might accidentally burn part of the meal. When things like that happened, Camille would begin to panic inside, and sometimes the panic would begin to spill out in the form of angry demands at the kids. Didn't they know their dad would freak out if he came home to things so out of order? Even if they had lost their respect for Jack, why couldn't they at least care enough about her to help make things run smoothly around the house?

Perhaps the children hadn't figured out the rules yet, though, because sometimes Jack came in happy from his day at work, and even when things weren't according to his specifications, he was cheerful and would joke around. But other times, even the slightest infraction against his wishes would send him into a rage. All Camille knew to do was to try and control every detail within her power and hope for the best. She bought the grocery brands Jack required and the other things he had approved for the kids and her. In the beginning of their relationship, he had accompanied her on all shopping trips until she had become clear about his wishes. It was fine for her to buy small personal items for herself as long as she stayed within the prescribed budget, but even then, she would only buy things she thought Jack would like. For instance, she knew if her clothes weren't baggy enough, it would, at the very least, result in a tortuous interrogation by Jack

about the men she might be trying to impress. If he didn't like her answers, he could easily become violent.

It's no wonder that Camille struggled with fear continuously. By this point in their marriage, Jack had fully conditioned her to live in the fear of him, rather than the fear of the Lord. It certainly would not have been wise for her to suddenly start telling him no—at least not without a good safety plan in place. If you find yourself in a similar situation, a local DV shelter can help you with safety planning,[13] but remember that moving forward victoriously involves so much more than escaping. It requires learning a whole new way of thinking *and of fearing*.

A Worship Problem

The Bible talks about both good and bad types of fear. For most of my life, I struggled with the worst sort of all—fear of man. It started long before I met Doug; he was simply able to recognize it, cultivate it, and use it as a weapon in order to gain complete domination over me. Therein lay the problem—someone other than my Lord had lordship of my life. Proverbs 29:25 proved to be a theme in my life before and after abuse. "Fear of man will prove to be a snare, but whoever trusts in the Lord is kept safe." Living in constant fear of my husband was surely a trap. I was so worried about his reactions that I lived my life in order to avoid any negative

[13] For more on safety plans, see http://ncadv.org/learn-more/get-help/personalized-safety-plan.

repercussions from him. The trouble was I couldn't do it! There was always something beyond my control that would set him off. *Whatever we fear controls us*, so he unconsciously became my lord. I'm sure that's one of the reasons God tells us to fear Him, so He has charge of our lives instead of something, or someone, else.

I used to shake my head when I read the history of the Israelites in the Old Testament. How could they have seen God's miraculous provision so many times and still turn to idols? It made no sense to me until after I got out of the abuse, and God showed me that my husband and my marriage had become idols. God had been so faithful to me over the years, yet I never yielded control of my life to Him. Why? Because I feared other things more. I feared my husband's temper, and I feared being divorced. For years, I did what I now call "the dance of fear." I tried to avoid his anger and the ending of our marriage, and I actually thought my efforts gave me some power over my circumstances.

Fear both controls us and compels us to try to control. All of my efforts amounted to attempts to be in charge of, or at least in control of, my husband's reactions. It took nearly losing everything for me to see I had only been fooling myself to think I had any power over such things. In this world, circumstances can change suddenly and dramatically for any of us at any time, and none of us have the ultimate charge over our lives. Yet that doesn't keep us from trying to run the show. Those who have lived with abuse tend to be the

worst when it comes to trying to micromanage things.[14] I suppose the same thing must have been true of the idolatrous Israelites. Certainly they didn't want to sacrifice their children to false gods like Moloch, but apparently, the fear of consequences for not doing it was worse than the prospect of doing it. When I look back at my life, I realize that fear of my husband caused me to put my children in a terribly destructive environment for far too long, but I believed I was holding it together. The reality was the exact opposite.

The first step to overcoming this vicious cycle of fear and attempted control is to replace the unhealthy fears with a proper fear of the Lord. It took me a long time to learn what that meant. For one thing, I wasn't quite sure what it looked like. I certainly didn't fear God the way I feared my husband. I knew God was love and that I didn't have to fear constant punishment with Him, but I must admit, I did struggle with thoughts that He could never be pleased with me. The interesting thing is that I cared a whole lot more about pleasing my husband than pleasing Him. Do you see the problem? Basically, misplaced fear leads to misplaced worship. In order to move forward, we must learn to put God on the throne of our lives rather than a man. For many of us, one of the first steps in doing that is to overcome our misconceptions about Him.

[14]I have also seen women try to escape the pain or "check out" through substance abuse or overuse of prescription medications. Although this reaction does not amount to micromanaging, it is still an attempt to control the situation by numbing the pain of living with abuse.

Perfect Love

First John 4:8 tells us that God is love, and then further down in verse 18, we are told that "perfect love casts out fear." When fear has been your constant companion for decades, it is difficult to imagine ever living without it, but this verse in 1 John gives us the key. Understanding and connecting to His perfect love will drive fear out. When children are afraid, it is normal for them to run to their parents. Even flawed, earthly parents will respond to their frightened children by holding them, and scripture gives us a beautiful picture of our perfect God doing the same for us. There are numerous verses that mention God hiding us in the "shelter of his wing" (Ps. 91:4, Ps. 17:8, Dt. 32:11, Ruth 2:12). Jesus also used this word picture in Matthew 23:37 when he lamented over the Holy City. "Jerusalem, Jerusalem, you who kill the prophets and stone those sent to you, how often I have longed to gather your children together, as a hen gathers her chicks under her wings, and you were not willing."

Have you ever seen a mother hen gather her chicks under her wings? They run to her for protection, and once they get under those wings, they are completely hidden. God longs for you to run to Him, but you must be willing. You must choose Him rather than your old ways of doing things. You must believe His promises and choose to run to the One who loves you most. When you know how great His love is, nothing can overwhelm you because you realize that, regardless of the outcome, you are in His care. He is bigger than anything that

causes you distress. If you still find it difficult to believe His love for you, see Appendix C, *Scriptures for Overcoming Fear and Anxiety.* I encourage you to study these passages, print or write out the ones that speak to you, and read them out loud to yourself often. Ask Him to help you find rest from anxiety in His loving arms and thank Him. There is power in praising Him because you are choosing to make Him greater than anything else vying for control of your life. It also helps to turn on worship music and sing along because you are choosing to focus on and exalt Him rather than your problems.

Holy Fear

"Twas grace that taught my heart to fear, and grace my fears relieved." I love that line from the song "Amazing Grace." It is an unbelievably powerful thing to exchange your unhealthy, sinful fear for the holy fear of God. Doing this means you will become concerned about respecting and revering your Lord first and foremost. It amounts to caring more about what He thinks than what anyone else thinks. This type of godly fear will help relieve ungodly ones. Jesus said no one can serve two masters—just as you cannot serve your husband and God. When you truly put God on the throne of your heart, you will not be easily manipulated by people.

When you care more about pleasing Him, you will want your responses to any given situation to bring Him glory. Those who live in fear usually seek the easiest path, but taking His path means loving others enough to

challenge their sin. Early in my marriage, I was able to stop the violence by taking a firm stand against it, but as my husband became more successful, I started to worry more about his reputation and what people might think. Caring more about pleasing God means you will seek His best in every situation, and being a slave to unholy fear is certainly not His best for your life. Neither is it the best for the one who is causing you to fear—it merely promotes their sin.

Making a Choice

When you make God your true Lord and begin to care most about pleasing Him, you will find yourself becoming more secure than you've ever been. Please note that, especially in the beginning, you may not *feel* secure. It often takes our emotions time to catch up with the truths our minds are embracing. Still, as you choose God's Word over your feelings, things will begin to change because He is faithful to keep His promises. As you learn to take your thoughts captive and surrender them to Him (2 Cor. 10:5), you will no longer be so easily devastated because you will know that the mighty God who created the universe holds you and promises never to leave or forsake you. What an awesome privilege! As His child, circumstances will no longer have the power to cause you panic because you will know that He is sheltering you beneath His wings. He has you, and He is more than able to help you survive the fiercest storms of life. Jesus gave us a beautiful word picture revealing the importance of making Him Lord in Matthew 7:24–27.

"Therefore everyone who hears these words of mine and puts them into practice is like a wise man who built his house on the rock. The rain came down, the streams rose, and the winds blew and beat against that house; yet it did not fall, because it had its foundation on the rock. But everyone who hears these words of mine and does not put them into practice is like a foolish man who built his house on sand. The rain came down, the streams rose, and the winds blew and beat against that house, and it fell with a great crash."

Notice this parable indicates that storms will come to everyone. Having your life grounded in the truths of His Word will not exempt you from trouble. Scripture is clear that we will all face difficulties in life, but God is faithful and can use even our difficulties for good (See John 16:33, Ps. 37:19–25, Rom.8:28–29). We may not be able to avoid suffering in this life, but we do have a choice about how it will affect us. If we allow improper fear to rule us, the trials of life will devastate and overwhelm us. However, if we choose to base our lives on His truth, we will stand firm regardless of our circumstances. My prayer for you is that you will choose to believe His promises and stand firm on the solid Rock because He is more than able to keep you secure.

Chapter 13
Knowing God

*"I consider everything a loss because of the surpassing
worth of knowing Christ Jesus my Lord."*
– Phil. 3:8

Identify with Christ

When somebody you love oppresses you, it can
begin to warp your view of God. Many times my
husband used scripture to keep me under control. Even
worse, I used it to convince myself that I had to submit
to just about anything and leaving the marriage was not
an option. "God hates divorce" was my mantra, and I
believed He would be angry or disappointed in me if I
gave up on my marriage. When the violence became so
deadly that I had no choice but to leave, I felt as though
I'd let God down. I also felt He had let me down. I had
done my best to live in obedience to Him, but He had
not saved our marriage. It seemed horribly unfair. Deep

down I really questioned His goodness. To move past my negative emotions, I needed to correct my concept of Him and realize He was not demanding that I stay in that deadly situation.

From the time things had started going terribly wrong in my marriage, I'd spent hours a day reading scripture and praying. Although I'd questioned God, I'd continued to seek Him because people offered no answers, and I was completely overwhelmed. The Bible studies I had done in the previous years served as an anchor for my afflicted soul. I knew I needed to choose to cling to His promises rather than to my feelings. So as I read His Word, I looked for His heart and found it. As Jesus's sufferings had touched my heart in the dumpster, they also became a source of comfort as I pondered scripture. "For we do not have a high priest who is unable to empathize with our weaknesses, but we have one who has been tempted in every way, just as we are—yet he did not sin" (Heb. 4:15). Scripture is filled with passages that point to Jesus's familiarity with pain and suffering (Is. 50:6, 53:3, Ps. 22:14–18, Mt. 26:6–7, Lk. 22:63–65, 24:20). He chose to suffer so He could know our pain and redeem us. As catastrophic as my circumstances were, they couldn't compare to what He had endured, and I thanked Him for His goodness toward me.

While I was grateful for Jesus, I still found myself struggling with the Father. My opinion of Him was different. Years ago, I heard a pastor say that we often form our image of God based on our earthly fathers, and

I believe to a great extent it's true. Even more so, our view of God can be warped by those who abuse us. I have counseled numerous women who were victimized by their fathers as children, and many have implied that being able to relate to a Heavenly Father is extremely difficult. Many of the women I've met coming out of domestic violence have seen God as stern and distant. Often, I ask them how they feel about Jesus and it's usually a different story. They can relate to Him because He was abused and rejected. It is helpful to remind these women of Jesus's words, "Anyone who has seen me has seen the Father" (Jn.14:9). Jesus perfectly reflected the Father's heart of love for us. It was crucial for me to recognize this truth and to challenge any faulty beliefs about His character.

For nearly two decades, I had been injured under the "authority" of my husband, and it damaged my trust of anyone in authority, including my Heavenly Father. Sadly, the way I interpreted some Bible passages further alienated me from Him. Rather than recognizing God's intent to provide protection for women, my interpretation of some passages on marriage caused misgivings about His nature. I realized I needed to change my views. Bible study proved to be very helpful when it came to doing this. As I pored over scripture, I found several verses that compared God to a loving mother and this mother's heart could relate to them. In Isaiah 49:15–16, God's response to His children who felt forsaken was, "Can a woman forget her nursing child, that she should have no compassion on the son of her

womb? Even these may forget, yet I will not forget you. Behold, I have engraved you on the palms of my hands." In Zephaniah 3:17, we get a picture of God singing over and holding His children, and in Isaiah 66:13, He promised to comfort His people as a mother comforts her children. Finally, Jesus used a motherly analogy when he lamented over Jerusalem in Matthew 23:37–39. His kindness and compassion were evident throughout the Gospels. He showed mercy when the religious were hard and judgmental. The stories of the woman caught in adultery in John 7–8 and the woman at the well in John 4 are prime examples of Jesus's love and compassion for individuals who were harshly judged by those who claimed to represent the Father.

If we see Him as demanding and unjust, we will harbor anger toward Him and carry unnecessary shame within ourselves. Even though I didn't verbalize it, this was a struggle for me. I had to recognize that the Father and Jesus are one (John 10:30) and it was wrong to see them so differently. The Father's heart was perfectly demonstrated in Jesus. It was the Father's loving plan that sent Him to suffer and die for us (John 3:16, Is. 53:10). As you identify with Christ's suffering and mercy, you must also identify with One who sent Him on your behalf. Identifying with Him in suffering certainly helped to change me.

Know His Love

Before suffering changed me, the things I valued were superficial. I constantly asked God to bless my

kingdom and was always anxious to get what I wanted—even if it was just a ceasefire. The thought of divorce shattered me, so I did everything in my power to avoid it. The problem was that my power was not enough, and it devastated me beyond words. Like the disciples in the storm on the Sea of Galilee, I found myself asking, Lord, don't you care if I perish? (Mk. 4:38). It is almost impossible to let go of bitterness if you don't understand that "He cares for you" (1 Pet. 5:7). The day He met me in a disgusting dumpster, He gave me a glimpse of His amazing love and let me know He chose to suffer on my behalf. During the worst time of my life, I made a choice to cling to Him and to believe His loving promises toward me. It is very helpful to meditate on scriptures that reinforce His loving intentions toward you. The "Scripture Database" (Appendix B) at the end of this book contains a section of passages about His love. Again, I urge you to find a few that speak to you, write them out, and repeat them often, out loud, until they sink into your heart.

Recognize His Sovereignty

God is able to hold you together because, ultimately, He (rather than your abuser) is in control. This truth was extremely helpful to me as I was coming out of abuse. In spite of the fact that He has given mankind freedom to choose sin, nothing can thwart His purposes (Job 42:2). He is powerful enough to work out His intentions, even when people act against His will. Believing He is sovereign is worthless if you do not

believe He loves you and is for you. Our Lord is a Redeemer. He promises to work all things together for the good of His children (Rom.8:28), but our problem is that we often interpret good as simply a change in circumstances. Immediately after reminding Believers of God's promise to work things together for good, the Apostle Paul stated that God intends for those who come to know Him to be "conformed to the image of His son" (Rom. 8:29).

I often say I would never have chosen the path of suffering that abuse brought me, but twenty-one years after the fact, I can honestly say I am grateful for what it accomplished in my life. At the time, all I knew to do was to hold on to God. I knew He was my only hope, and even though I struggled through fear, doubt, and anger, He used it all for good. When I look back at that horrible period of my life, I always think of Philippians 3:8: "I consider everything a loss because of the surpassing worth of knowing Christ Jesus my Lord, for whose sake I have lost all things." In my suffering, it seems as though I lost everything, and found everything, all at the same time.

Chapter 14
Find Your Worth in Him

*But you are a chosen race, a royal priesthood, a holy
nation, a people for God's own possession, so that you may
declare the goodness of Him who has called you out of
darkness into His marvelous light.*
— 1 Peter 2:9

Many of us identify ourselves according to our
relationships in life. For those of us who've suffered
abuse, this can be a real problem because we view
ourselves based on what has happened to us in the past,
rather than basing our view on God's truth. In order to
heal and move on, we have to realize that we are not
defined by what has happened to us! Every time I start
teaching on this subject, the name of a dear friend comes
to mind because she refused to let a tragic past become
her identity.

A little over a year ago, I had set up a display for

our ministry at an event and a lady named Latonya Allen stopped to read the display.

She said, "We need to talk," and then proceeded to tell me her story.

She explained that two years earlier, her estranged husband had murdered both of her parents, then beat her and shot her and left her for dead. Her children, who had been hiding in a closet, were able to call 911. Although Latonya was still alive when medics arrived, the prognosis was grim and the family was planning three funerals. Doctors told her family that if by some miracle she did live, she would have multiple complications and her quality of life would not be very good. She lay in a coma for a week, but at the end of that week, she suddenly woke up. To hear her tell it, she woke up knowing that God had touched her and saved her life for a reason. She woke up filled with gratitude.

As she was telling her story, I was so amazed by her sweet spirit. She didn't seem traumatized, bitter, or fearful, but rather truly grateful. In the months since we've met, I have watched this dear woman share her story and use her past as a catalyst for change. She's honest about her struggles but knows that He is redeeming all she and her children have suffered. When I see Latonya, I am overwhelmed with God's goodness because I see how He is holding her up, and I see that all things are possible with Him. My dear friend knows that she is precious in His sight and that knowledge has brought an amazing amount of healing to her life.

Not understanding your value to God can keep you

from ever moving past the abuse you've endured. It's important to try to see yourself as He sees you. If we allow our self-image to become tied up in wrong things, we can end up either extremely proud (like many abusers) or feeling worthless (like most survivors). Both extremes focus on self rather than God. Some symptoms of not knowing your identity as His child include insecurity, judgmental attitudes, pride, defensiveness (when someone disagrees with your ideas, you see it as a rejection of you), hardness, distrust (self-protection), disrespect, and jealously. Not understanding who you are in Him can also manifest as a competitive spirit, perfectionism, rebellion, pretense, controlling of others, and escapism (addictive behaviors). Neither of the extremes—pride or feelings of worthlessness—are an accurate reflection of who we are in Christ. We have no reason to be proud, and we have no business acting like we are worthless; He thought we were worth giving up His life.

Because of what Jesus did for us on the cross, we can become new creations (Eph. 2:8–9, 2 Cor. 5:17) and our response should be gratitude rather than pride or shame. The human race was created faultless in His sight. We were created to have fellowship and intimacy with God, but when sin entered the world, that fellowship was broken. Thankfully, He loved us enough to pursue us, even after we rejected Him. Jesus came to earth to restore our broken relationship with God. He became sin on our behalf so we could become "the righteousness of God" (2 Cor. 5:21, 8:9). It is interesting

that Jesus taught us that denying ourselves was one of the keys to finding abundant life, and some misinterpret that to mean we must degrade ourselves. However, I believe this simply means that as we move our focus from self to God, we will find the joy and freedom He intends for us (Mt. 16:24–25). Self-image problems are also worship problems. Whatever consumes the bulk of our thoughts will become our object of worship. If we are meditating on anything other than Him, we will find ourselves controlled by fear and filled with either pride or shame.

He has given us a glorious identity and when we embrace that truth, we will be filled with gratitude, rather than feelings of worthlessness. Listed below, you will find just a few truths from scripture to help you better understand your worth in Him. I suggest you take some time this week to look them up and journal your reaction in prayers to the One who treasures you most.

- We are fully known and loved. – Psalm 139, Luke 12:4–7
- We are reconciled, holy, and beyond reproach in Him. – Colossians 1:21–22
- We are blessed with every spiritual blessing (look them up and list them). – Ephesians 1:3–14
- God is for us and we are more than conquerors. – Romans 8:31–39
- We've been chosen by the king, even though we had nothing. It is solely by His grace. – 1 Cor. 1:26-30

How Knowing Your Worth Affects Relationships

Until you know these truths about your worth in Him, you may easily find yourself repeating the cycle of abuse in future relationships. I often tell people that getting a victim out of an abusive relationship is very much like getting someone out of a cult. I have seen the struggle firsthand and have also lived it. Looking back on the journal I wrote during the years I was living with abuse, it is clear that my thinking had become warped and I had been programmed (perhaps even brainwashed) to accept behavior I would never have accepted in the beginning of our relationship. I was conditioned to believe that I was supposed to put up with it. This is the deceitful nature of abuse. Ladies in our support groups tell me that over time, they also came to tolerate more and more cruelty from their partners, and in the end, they found it nearly impossible to leave men who had repeatedly harmed them. Not only was it difficult to leave, but many also found themselves longing to be back with their abusers. Circumstances had to become so damaging that staying was no longer an option, but even then, they found themselves consumed with grief over the loss of their relationships. It seems to defy all logic that something so toxic could be so appealing.

When I was finally able to break free, I determined I would learn all that I could to avoid repeating the cycle of abuse in the future. God was faithful to help correct my warped thinking with His truth, but in the beginning, I *longed* to be in a relationship with someone.

I felt like I desperately *needed* to be in a relationship. Fortunately, my fear of being hurt and my legalistic thinking about divorce and remarriage kept me from putting myself out there, but this hasn't been the case with many of the ladies I've worked with over the years. In fact, many of them are quick to jump into new relationships, and some find themselves facing abuse again. In fact, this became the theme of our local support group a few weeks ago. Two of the ladies told of how they had been snagged by abusers a second time around. One said, "There's comfort in what you're used to. It just felt normal to me."

I think the abuse felt normal because these dear ladies had never overcome the brainwashing that occurred with their first abusers. If domestic violence is anything, it is mentally deceptive. It involves mind games that systematically destroy our confidence and sense of self-worth. It conditions us to tolerate the intolerable and to doubt our own instincts. Overcoming this doesn't happen quickly, but it's not impossible. In my case, scripture had to be the standard. I had to learn to identify my faulty thinking and replace it with His truth—truths like I am loved and highly valued by God (Ps. 149:4, Zec. 2:8, Zep. 3:17), that fear of man is a snare (Pr. 29:25), and that He calls us to peace (1 Cor. 7:15). Even then, it was hard to break old habits. When I met my second husband, I immediately found myself walking in fear of his reactions even though I had no reason to fear. Very quickly, pleasing him became more important than pleasing Him, and it didn't take long for

trouble to come. I had been so accustomed to living for the approval of people that I found it easier to lie than tell the truth in order to avoid disapproval. After this harmful dynamic nearly destroyed my second marriage, I let our crisis become a catalyst for change in me. God taught me a huge lesson in that whole ordeal. When I learned to fear Him more than my husband, things began to turn around.

If we get into a new relationship and find ourselves stressing about how to please a man, we are already off to a bad start. It is unhealthy to live to please a man and to feel like we need his approval to have fulfillment in this life. I've often said that abusive relationships are addictive because we feel as though we can't survive without our partners. Sadly, that gives them complete control over our lives. The only One worthy of such esteem is God, and He is not a control freak. He also loves us exactly as we are. We don't have to jump through hoops to win His approval. He desires the best for us, rather than harm (Jer. 29:11).

He is completely trustworthy and able to keep us from harm when we choose to walk in truth. And guess what? He does not condemn you for making the same mistake twice, or even three or four times. Jesus went out of His way to meet a shamed woman at a well in Samaria. She had been married five times and was living with a man who was not her husband. Yet, He pursued her and offered living water to satisfy her longing soul (John 4), just as He is pursuing you and wants to satisfy your deepest longings. Abusers set us up to believe we

need them to exist. They condition us to long for them in order to find meaning, but they are like broken cisterns that can't hold water (Jer. 2:13). You'll never be satisfied. God invites you to come and drink freely from His water of life and promises that you'll never thirst again (Rev. 22:17).

Chapter 15
Break the Victim Mentality

When Jesus saw him lying there and learned that he had been in this condition for a long time, he asked him, "Do you want to get well?"
– John 5:6

By the time I realized I would not be able to reconcile with my husband, I had lived with abuse for nearly two thirds of my life, and finally breaking free was the hardest thing I've ever done. In the final years of that relationship, I lost nearly all my worldly possessions. I faced great financial loss, angry children, and continued threats on my life. I had nightmares and found myself freaking out about little things that had nothing to do with me. Essentially, I had all the signs of PTSD. When I heard people around me complain about everyday struggles, I wanted to laugh in their faces and say, "Are you kidding me? That's nothing!" I wanted the

world to know that I had been wronged, and I expected the world to somehow come make it right.

The odd thing is, the more I complained, the less people wanted to listen. They seemed to alienate themselves from me, which made my situation even more miserable. I could have stayed in that pattern forever, but as I cried out to God, I began to realize that I would never be an overcomer until I dropped my victim mentality. I realized that people did not know how to handle the severity of my losses. I am sure it made them uncomfortable—perhaps even guilty—that they had been blessed with easier lives. I realized I needed to stop making my unfortunate past my identity, so I made the decision to pour my complaints out to God rather than to people. I decided to believe His promises to me rather than my feelings. Although that decision did not immediately change my circumstances, it did make all the difference in the world in me. Today I am a victor rather than a victim because I *chose* to believe Him.

In the years since I transitioned from victim to victor, I have had many opportunities to work with other victims. I have seen some apply themselves to the truths of God's Word and blossom before my very eyes. In those cases, it has truly been like watching butterflies come out of their cocoons. From all outward appearances, their situations seemed hopeless, but God has performed miracles for those who have learned to trust Him. Trust like this involves a decision to believe God rather than to rely on emotions and past experiences. I have never seen God disappoint those

who have chosen to really trust Him. The outcome has always been beautiful.

On the other hand, some of the women I have tried to help have refused to let go of that victim mentality. When I direct them to God's promises, they give me a thousand reasons not to believe them. This attitude reminds me of the man Jesus healed at the pool in Bethesda in John 5. Even though he stationed himself in the place where the angel stirred the water to be healed, he basically told Jesus it was impossible because somebody always beat him to the water. He was full of bitterness and excuses. When Jesus healed him in spite of his negativity, he showed no joy nor did he stop to thank Jesus. Instead, when the religious leaders rebuked him for carrying his pallet, he *blamed* Him. Jesus knew his heart and came to him later with a warning, "See, you are well again. Stop sinning or something worse may happen to you" (5:14). But he simply went out and reported Jesus to the leaders. He had been set free, but he chose to remain bitter.

That's the problem with so many victims; they fail to see and appreciate God's provision in their lives. Instead, they choose to stay bitter and make excuses for hanging on to their anger. They essentially cut themselves off from God's blessings and blame everyone around them (even God) for their negative circumstances. I love to contrast the story of the man at the pool with the healing of the man born blind in John 9. When Jesus healed the blind man, his life was changed immediately. He became a believer and was

willing to profess his faith in spite of harsh opposition. As far as outward circumstances go, he probably fared worse than the man healed at the pool. Yet, he was filled with joy over what Jesus had done for him. Like King David (who spent years running from abuse), he chose to praise God in the presence of his enemies rather than cling to bitterness.

The truth is that bad things happen in this fallen world. Many of us end up as victims at some point and it grieves God's heart. We suffer unjustly and it isn't fair, but God knows exactly how that feels (Heb. 4:15). Our God is a redeemer, though, and nothing is wasted when we know Him. He can turn our mourning into dancing (Ps. 30:11) and use tribulation to mold us into the image of His son (Rom. 8:29). But in the midst of our troubles, we must choose to trust Him. We must choose to let go of the bitterness that poisons every relationship in our lives and keeps us in bondage (Heb. 12:15). The problem with victims is they are often not willing to make this choice. Instead, they hold tenaciously to their right to be miserable and angry, and they unwittingly finish the job their enemies began.

Resolve to Move Forward

If you're reading this book, I assume that you, or someone you know and love, has experienced abuse. Some people never recover from the trauma of domestic violence, so you may be wondering if there really is a way to move from victim to victor. Once you get yourself in a safe place, resolve to become an overcomer.

122

You will need to learn and claim God's promises over your life. Choose to *reprogram your thoughts* to line up with truth from His Word, refuse every deceptive thought (2 Cor. 10:5), and decide to dwell on things that are good (Phil. 4:6-8). I often have counselees set a timer to check their thoughts throughout the day. Examine what you think about most in the light of scripture. Does it line up with His truth? Remind yourself that He promises to work all things together for our good (Rom. 8:28), He always leads us in triumph (2 Cor. 2:14), and He uses trials to build character in us (Rom. 5:3-5). His Word is full of promises to those who are afflicted: "We are hard pressed on every side, but not crushed; perplexed, but not in despair; persecuted, but not abandoned; struck down, but not destroyed" (2 Cor. 4:8–9). I held tightly to passages like this. I also camped out in Psalms for a few years and found great comfort in them—particularly 27, 34, 46, and 56. I simply had to remind myself that God is for me. When the person you love most has been against you for so long, sometimes it's hard to believe that anyone can be on your side. That is why you must learn to counter negative thoughts with the truth about who He is. As I was coming out of the abuse, I came up with my own personal scripture database to remind myself of His wonderful promises and made cryptic notes beside these passages to remind myself of the truths I wanted to remember (see Appendix B). My thinking had been warped by the years of the abuse, so I made a decision to change my thoughts and beliefs. I encourage you to take these

promises, write them out, and recite them out loud often to remind yourself as well.

For many of us, doubting God is the biggest hurdle to overcome, but for others it may be issues we've tackled in other chapters such as unforgiveness, anger, fear, or even idolatry. Some of us may actually crave the attention or sympathy we get when people find out what we've experienced. After all, living through domestic violence can be every bit as traumatic as going to war. In my own case, the inability of the church to help me deepened my sense of bitterness. Over the years, I have often seen churches believe abusers and dismiss the victims' claims. Some have even gone so far as to bring victims up on church discipline for leaving the violence or for being "unsubmissive." There's no doubt that many victims are re-victimized again and again, from their churches to the courts—justice often seems illusive, and true support is difficult to find. I've seen women move from million dollar homes to bare-bones lifestyles. This lack of resources can add to the bitterness of being abused and betrayed by the one who was supposed to love and protect them. All in all, moving from victim to victor is extremely difficult! However, with God all things are possible.

We serve a God who specializes in redemption. This means He can take the worst of human suffering and use it for good. The ultimate example of this is seen in Jesus. He willingly came into the world and suffered in order to reconcile us to God. He was despised, rejected, and abused beyond recognition; yet, God had a

good plan. I love to read Isaiah 53, which describes Jesus's earthly suffering, to abuse victims because I want them to know that God truly understands their suffering. Hebrews 12:2 tells us that Jesus endured the shame and misery of the cross because of the "joy set before him." He knew the Father's plan was to use it in order to reconcile a lost world to Himself, and He knew it would allow Him to fully relate to those who suffer. Before I go any further, let me just say that *I am not saying you should stay and suffer abuse*! By all means, you need to get yourself, and your children, out of harm's way! What I am saying is that in order to move past your victim status, you need to recognize that God wants to take and redeem your pain.

Consider the story of Joseph found in chapters 37–50 of Genesis. When his wrongful suffering was over, God used him to save a whole nation, as well as the same brothers who had betrayed him. Although he had the power to destroy them, he chose mercy instead. Genesis 50:20 is one of my favorite Bible passages. It records Joseph's response to his brothers when they stood before him seeking forgiveness. While many people would savor the opportunity to get even, Joseph pointed to God's sovereign and good purposes. He told them, "As for you, you meant evil against me, but God meant it for good in order to bring about this present result, to preserve many people alive" (NASB).

Do you believe God could ever use your suffering for good? I can tell you, without doubt, that if I had not suffered abuse, I wouldn't have written this book, and I

have had many women tell me that my story has given them hope to overcome their abuse. I can also tell you that my experiences drove me into my Savior's arms and deepened my relationship with Him beyond anything I would have ever imagined. People who remain victims are too self-consumed to help others, but God wants us to use our pain to help others. "Praise be to the God and Father of our Lord Jesus Christ, the Father of compassion and the God of all comfort, who comforts us in all our troubles, so that we can comfort those in any trouble with the comfort we ourselves receive from God" (2 Cor. 1:3–4). It's not easy, but God has given you all the resources you need to overcome. You have the very same Spirit who raised Christ from the dead dwelling in you (Rom. 8:11)! You also have His Word, which is alive and active to perform the spiritual surgery needed for change (Heb. 4:12). You have a choice. You can allow our Lord to use your suffering for good, or you can let your past define you. My prayer is that you will choose God's way and make the transition from victim to victor.

Appendix A - Power & Control Wheel

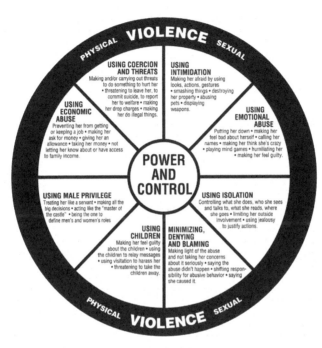

*Used with permission from the Domestic Abuse
Intervention Program (DAIP) of Duluth, MN*
www.duluth-model.org

Appendix B - Scripture Database

ANGER

- Jonah 4 - Jonah's anger at God's mercy.
- Eph. 4:26 & 31 - Do not sin in your anger.
- Col.3:8 - Put anger aside.
- Galatians 5:16–20 - A deed of the flesh will affect our inheritance in the kingdom.
- Jas. 1:19–21 - Anger does not achieve the righteous life God desires for us. Our anger is rarely righteous.
- Luke 9:54–56 - The disciples ask Jesus to pour out wrath on those opposed to Him.

ANXIETY

- Matt. 6:25–34
- Phil.4:6–9
- I Pet. 5:7

COMFORT

- Isaiah 54:11- The storm tossed, but God rebuilt.
- 2 Cor.1:3–4 - God comforts us so we can comfort others.
- Heb. 4:15 - He knows our affliction and is touched by them because he has experienced similar experiences.

CONFESSION

- Ps. 32 & 51

FEAR

- 2 Ch. 20:15 - The battle is not yours, but the Lord's.
- Ps. 56:3–4 - When you are afraid, put your trust in God. What can mere man do to you when God is with you?
- Isaiah 51:12–14
- Zep. 3:16–17 - The Lord is in your midst. He will quiet you with His love and will sing over you.
- John 14:27- Don't let your heart fear; you must choose to believe.
- Psalm 34:4–6
- Ps. 46:1,7
- Is. 41:10
- Rom. 8:15
- Psalms 27 & 46

FEAR OF MAN/CONFRONTATION

- Proverbs 27:5–6
- Matt. 10:28 - Don't fear those who can destroy the body.
- Rom. 14:23 - Fear of man/confrontation is sin.

- Heb. 13:5–6 - Be content in Him knowing that He'll never desert you.
- Galatians 1:10 - We cannot please both man and God. We serve those we fear.

FORGIVENESS

- Mt. 6:12–14
- Mt. 18:21–35 - God has forgiven us of every murderous/adulterous thought (Mt. 5:21-28), we must extend the same grace to others.
- Mk. 11:24–26
- Eph. 4:32
- Col. 2:13 & 3:12–13
- Matt. 5:23 - If you are presenting your offering and remember someone has something against you, God says to make amends first. This only works in normal relationships, though. With abusers, we often have to go to God instead and ask Him to rid us of unforgiveness.

GOD'S LOVE

- Ps. 56:8–9 - God watches over you. God is on your side.
- Is. 53 - He willingly came and suffered because of His love for you.
- Ps. 57:1–3

- Isaiah 49:14–16 - People may forget, but God never forgets.
- Zep. 3:16–17 - He rejoices over you with singing.
- Is. 54:4–8 - The Lord, your maker, is your husband.
- Psalm 130
- Rom. 8:15, 31–37 - We are His children and nothing can separate us from His love.

GRIEF

- I Thes.4:13 - We can grieve with hope.
- 2 Cor. 5:1–8
- 1 Cor. 15:35–57

GUILT

- 1 Jn. 1:9
- Heb. 10:19–23
- Psalm 32:1–5 - Until we confess our sins, there is misery, but there is peace in the blessing of His forgiveness.

HOPE

- Jeremiah 29:11–12
- Romans 8:28–29
- Ps. 25
- Psalm 34:19

- Psalm 42
- Psalm 130
- Isaiah 50:2
- Romans 8:31–37 - We are more than conquerors.
- Ps. 55:18 - God will redeem your soul, He will give you peace to help you recover from the battle against you.
- Ps. 56:9 - God is for you!
- Isaiah 54:11–17 - Our heritage as His children.
- 1 Cor. 1:19–20

INADEQUACY

- Phil. 4:11–13
- I Tim.
- 2 Sam. 22: 28–30
- Psalm 18:28–36

OVERCOMING

- Phil.3:12–14 - Forget the past and look forward.
- Phil. 4:13 - We can do all things through Christ
- 2 Pet. 1:3–4 - His divine power has given us everything we need pertaining to life.
- 2 Cor. 12:7–10 - God has strength in our weakness.

PRIORITIES

- Phil. 3:7–15

THOUGHT LIFE

2 Cor. 10:3–5 - We must take every thought captive.

Phil. 4:8–9

Isaiah 26:3–4

Ps. 16:7–11 - Praise the Lord who has counseled you.

TRIBULATION

- 2 Cor. 4:17–18 - Our troubles are light, momentary afflictions working for eternal good in our lives.
- Heb 12:2–4 - Look to Jesus—the author and finisher.
- Rom. 5:2–3 - Rejoice in suffering, it produces perseverance.
- Rom. 8:18 - Our sufferings are nothing in comparison to the glory waiting for us.
- Jam. 1:2
- Phil. 3:7–10
- Psalm 32:6–11 - God surrounds us with songs of deliverance.
- Psalm 119:67 & 71 - God uses the affliction to sanctify us.

- Psalm 25 - Look to the Lord, for He alone can rescue us.
- I Cor. 10:13 - God is faithful. He won't let us be tempted (tried) beyond what we can bear. Other people have faced similar trials—and Jesus has faced even worse.
- 2 Cor. 1:3–11

SATISFACTION IN HIM

- Hab. 3:17–19 - Though bad things are happening, rejoice in Him.
- Psalm 42 - You should long for Him as a parched animal longs for water—instead we seek cheap substitutes.
- Psalm 17:8 & 15 - He treasures you. Be satisfied in Him.
- Jer. 2 & 3 - We often turn from God and seek other things/ways to find satisfaction, but it leads us into misery. God compares this kind of idolatry to unfaithfulness in marriage, yet He longs to heal and restore.
- Jer. 9:23–24 - Boast only in knowing Him.
- Ps. 16:11 - In His presence, there is fullness of joy.
- Ps. 34:8–9 - Taste and see that the Lord is good.
- Hebrews 13:5 - He will never leave or forsake you. Be content.

SELF PITY

- Jonah 4
- 1 Cor. 15:19 - We have eternal hope beyond temporary circumstances.
- Mt. 16:24 - We must deny ourselves.

TEMPTATION

- I Cor. 10:13
- Hebrews 4:14–16 - Jesus was tempted in every way and is still without sin. He was able to say no to temptation. He is our priest and enables us to approach the throne of grace with confidence. Grace will aid us in times of trouble.
- 2 Cor. 12:7–10

TRUTH

- Jer. 17:9 - Truth is not in us, but in Him.
- John 8:32 - The truth sets us free!
- Psalm 51:6
- Psalm 119:160 & John 17:17 - His word is truth.
- John 14:6 - Jesus (the Word made flesh) is the truth.
- Phil. 4:8 - Think on things that are true. We must replace the lies we believe with His truth.

Appendix C - Scriptures for Overcoming Fear and Anxiety

- 2 Ch. 20:15 - The battle is not yours, but the Lord's.
- Ps. 56:18 - When I am afraid I put my trust in You...what can mere man do to me?
- Isaiah 51:12–14 - I am He who comforts you. Who are you that you should fear the oppressor bent on destruction?
- Zep. 3:16–17 - The Lord is in your midst, He will quiet you with His love...will sing over you.
- John 14:27 - Don't *let* your heart fear...you must choose to believe.
- Psalm 34 - Seek the Lord and He will deliver you from all my fears.
- Ps. 46 - He is a very present help in trouble.
- Is. 41:10 - Don't be afraid. He will strengthen you
- Rom. 8:15 - We have not received a spirit of fear.
- Psalms 27 - My heart will not fear (regardless of the circumstance).
- Matt. 6:25–34 - Do not worry.
- Phil.4:6–9 - Do not be anxious.
- I Pet. 5:7 - Cast your anxieties on Him.

Fear of Man/Confrontation

- Proverbs 27:5–6 - Better an open rebuke than the wounds from a false friend
- Matt. 10:28 - Don't fear those who can destroy the body.
- Rom. 14:23 - Whatever does not come from faith is sin.
- Heb. 13:5–6 - Find contentment in Him knowing that he'll never desert you
- Galatians 1:10 - You can't aim to please/serve man and also be a servant of God. We serve whomever or whatever we fear.

Biblical Examples - 3 Kings

- Saul - 1 Sam. 28:5–20 - Saul grasped for control
- David - 1 Sam. 30:3–6 - David strengthened himself in the Lord (Ps. 27:3)
- Hezekiah - 2 Ki. 19:14–19 - Hezekiah brought his fears to God and chose faith

Note: Scripture is filled with passages about fear, and contains 365 commands not to be afraid (once for each day of the year)! These verses are just a start. If you struggle with fear, you will find lots of good company in scripture—from the likes of Saul who chose to handle it in his flesh and destroyed himself, to David who brought his fears straight to God and waited for his redemption. Each time fear rolls in, we have a choice to make. We can either give in to it, or choose to believe God.

Made in USA - Kendallville, IN
1231610_9781948449014
02.11.2021 0810